Mrs. Charles Darwin's

RECIPE BOOK
Revived and Illustrated

First published in the United States of America in 2008 by
Glitterati Incorporated

225 Central Park West, Suite 305
New York, New York 10024
www.GlitteratiIncorporated.com
Telephone 212-362-9119 / Fax 646-607-4433
www.GlitteratiIncoporated.com
Email glitterati@verizon.net for inquiries

Photographs by Adam Forgash
Recipes executed by Jonathan Forgash
Editor: Signe Bergstrom
Design: Sarah Morgan Karp/smk-design.com

Special thanks to Lester Gribetz, Jessica Stevens, and Michelle Richards of Waterford Wedgwood
U.S.A. and Hugh Lavery of Waterford Wedgwood Dublin; Tori Reeve at Down House, Downe,
Kent, England; Stephen Sinon at the New York Botanical Garden; Peter Fox at Cambridge University Library, Cambridge, England.

First edition, 2008

Library of Congress Cataloging-in-Publication data is available from the publisher.

Hardcover ISBN 13: 978-0-9801557-3-0

Printed and bound in China by Hong Kong Graphics & Printing Ltd.

10 9 8 7 6 5 4 3 2 1

Mrs. Charles Darwin's

RECIPE BOOK
Revived and Illustrated

DUSHA BATESON AND WESLIE JANEWAY

PREFACE BY Janet Browne ❧ FOREWORD BY Nach Waxman

Glitterati
INCORPORATED

TABLE OF CONTENTS

PREFACE

NOT SO WIDELY known as other notable Victorian women, Emma Darwin lived nearly the entire length of the nineteenth century. When she was born, in 1808, the ruling monarch was King George III. In that same year, Beethoven premiered his Fifth Symphony, Goethe published the first part of *Faust*, and Napoleon's armies were marching in ever widening arcs across Europe. By the time of her death in 1896, the world she knew was utterly transformed. The British Empire was rapidly expanding, science and technology were advancing in dramatic ways, and society and culture were very different from the days of her youth. As a girl, Emma traveled by horse and carriage and read Jane Austen. In the last decades of her life, she encountered the beginnings of modernity. She tried an early form of telephone, saw one of her sons stand for Parliament, read Robert Louis Stevenson, and wondered, with some misgivings, whether her granddaughters should ride bicycles in the street. Throughout, she remained a remarkable woman.

Married to her cousin Charles Darwin, she experienced many of these changes at first hand, for her own husband emerged as a central figure in the intellectual, biological, and theological revolutions of the nineteenth century. His writings on evolution by natural selection confronted everything that had previously been thought about the history and origins of living forms, and his book *On the Origin of Species* made him one of the most celebrated thinkers of his day. Through the years of controversy and debilitating private illness that followed his publication of this notorious volume,

Emma Darwin cared for her husband with love, resilience, and a great deal of good humor. She provided the emotional security that Charles Darwin needed to bring his great intellectual project into the public domain.

But Emma Darwin should not be encountered merely as an appendage to her famous husband. Much of her lively character emerges in her letters, published after her death by her daughter Henrietta Litchfield. Naturally the round of family visits and daily life took precedence. Emma was the granddaughter of Josiah Wedgwood, the pottery manufacturer and industrialist, one of the most important individuals in revolutionizing European consumer taste in the eighteenth century. This branch of the Wedgwood family was prosperous and well connected, including close personal ties with the Darwin family of Shewsbury. Josiah Wedgwood's daughter Susanna married Robert Waring Darwin in 1796, soon becoming parents to a large family that included Charles Darwin. Emma's marriage to her cousin Charles in 1838 strengthened an already tightly knit family community. She regularly exchanged letters with many members of the combined Darwin-Wedgwood circle, and increasingly with growing numbers of children, nieces, and nephews. These letters provide marvelous—and frequently amusing—insight into her life with Darwin. It could almost be said, too, that these letters describe what it might be like to live with science, for over the years she came to know many of Darwin's scientific friends and acquaintances, and often welcomed into her home his colleagues, such as Thomas Henry Huxley. She writes with humor about the activities of a large Victorian household and the village in which the family lived. Her letters indeed have much to tell historians about the structure of domestic life during the most formative years of the century.

Yet, like many other Victorian women of her social background, Emma had another voice, a voice that is less often heard because of the scarcity of archival materials. Emma Darwin ran the household and carried out many

small charitable activities as was customary for women of her status. We know this, not just from Darwin's recollections, or from those of her children and friends, but more especially because Emma kept a set of domestic accounts for nearly fifty years that documented her kitchen expenditure and other household costs, including wages for the female servants. Her account books included categories for meat, candles, groceries, soap, loaf-sugar, tea, eggs, bread, and so forth, to a total of twenty headings.

And, as this volume edited by Dusha Bateson and Weslie Janeway so charmingly displays, she also kept a recipe book. This recipe book reflects her position as the individual responsible for feeding the family, entertaining, and maintaining the domestic space. While her husband kept a careful eye on the external financial affairs of the family, Emma Darwin directed the kitchen staff, kept accounts, and looked after the household concerns. To be able to read her recipes today is therefore to have remarkable access to the inner recesses of a prosperous Victorian home. Moreover, it has long been appreciated that food, and the serving of food, lies at the very heart of the social process. The editors have performed wonders not only in making this manuscript volume accessible but also in setting the recipes in context. All the dishes have been researched, explained, and adjusted. Here we can almost see the Darwin family as they sit around the table.

This revived and expanded volume of Emma Darwin's recipes is extremely welcome for another reason. Over the years, a number of us working in the Darwin archives have attempted to give parties following Emma's instructions. Now guests will simultaneously be able to enjoy real food and the quirky pleasures of dining with history.

—JANET BROWNE

FOREWORD

FOR BETTER OR for worse, only a very few members of our species (surely an appropriate word to be used here), ever achieve fame. And it is an historic truth that all the rest of us—those who happen not to be heroes, saints, geniuses, leaders of nations, unimaginably wealthy or unspeakably evil—are boundlessly curious about the lives of those whose reputations have propelled them into realms about which we may speculate but which we can never inhabit. King Solomon's subjects may have traded gossip about his wisdom and his wives; the faithful are curious to know what the Pope thinks about at breakfast. How did Confucius get along with his brothers and sisters? What sparked the imaginations of Galileo? Of Catherine the Great? Of Mary Shelley? What kinds of things made Napoleon laugh? What did John D.Rockefeller read before he went to sleep? Did Virginia Woolf enjoy listening to the radio? Where did Einstein get his clothes? What did Charles Darwin eat?

There is something irresistible in discovering the details of the lives of the great. What did they do that was different from the rest of us? And, on the other side, what was common to their lives and ours?

Food, surely, seems to provide one doorway, or at least a peephole, into our understanding of both our own lives and the lives of the famous. How and what they ate is of interest, because it adds color, dimension and, of course, flavor to our knowledge of what they did—beyond making their fortunes, founding their empires, or inspiring us with their art and their

music. From the self-starving saint to the gluttonous English monarch, from Samuel Johnson, forced at times onto an invalid diet while battling his gout, to George Bernard Shaw, that exuberant vegetarian, we learn much about the whole person, much about the daily life of the great, not just about the enduring accomplishments that make us know their names.

The bringing to light—and now the publication—of Emma Darwin's kitchen notes offers one of those rare opportunities to get a glimpse of one corner of the life of a great scientist. It is a corner that has nothing to do with epic voyages and amazing discoveries, with the exotic shapes of the beaks of birds, and with plants and animals struggling along their paths to survival on bleak islands and in teeming jungles. It has to do with break-fasts with the family, with company dinners, with the rich, substantial foods of the Victorian world, with soft and soothing foods undoubtedly needed for Charles' chronically poor digestion. This is very much the food of its time, some quite old-fashioned, what Emma herself might have grown up on, some much more a la mode, reflecting the prosperity of families such as the Darwins and the Wedgwoods and their increasing distance from the simplicity of farm and field.

Documents of this sort have proved worthwhile discoveries, not just for those engaged in the study of social or gastronomic history. They are rarely about culinary invention. The authors point out in their enlightening introduction that most of the recipes are not Emma Darwin's creations, nor, it is quite possible, may she even have executed many of them herself. But they were her selections, or in some cases possibly suggestions shared with her by friends and family. Such household or kitchen books, a tradition go-ing back at least three or four hundred years, are clues to the lives of fami-lies—their tastes, their willingness to adventure (in Emma's case, probably not much), the things that give them pleasure and comfort, the style of their

home and their daily life. Do the foods that appear on these pages speak to the scientific genius of Charles Darwin, to his struggle to open the eyes of a largely resistant public to the world they occupied? Clearly not. But do they fill out our picture of the human being who so changed our understanding of life on earth? Do they allow us to see him at table with his family, perhaps sharing these dishes with such allies as Thomas Huxley and Joseph Hooker, discussing the issues of the day, and being very much the people of their historically momentous time, right on the edge of changes that would alter our understanding of life forever? Yes, the food does have something to say, as much as the reports that Darwin read in his newspapers, as much as the drawings that hung on his walls, as much as the sermons offered at church, as much as the magazines showing Emma the latest fashions coming in from Paris. They all help define the world in which Darwin lived and worked and thus enrich our understanding of his life and his accomplishments.

What a fine and useful addition this is to knowing both the food of a particular time in history and the great person who was nourished by it. We owe Emma Darwin our gratitude for her little book.

—NACH WAXMAN

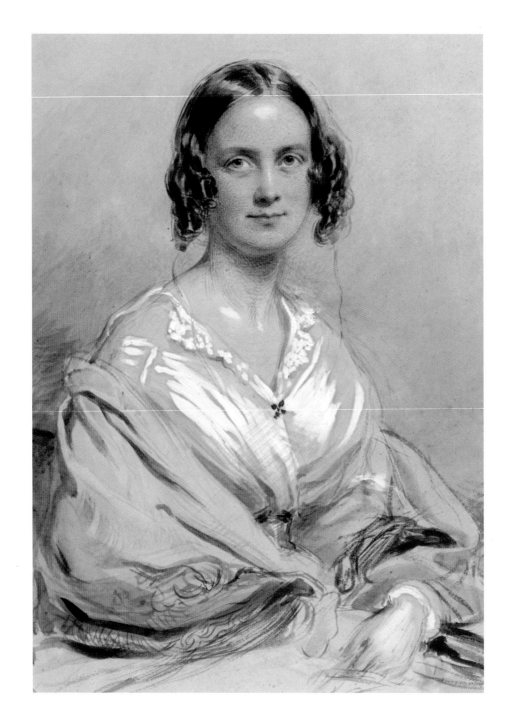

INTRODUCTION

AN INTEREST IN cooking leads, invariably, to an untidy accumulation of recipes. Whether cooking for yourself, your family, or more ambitiously, to entertain friends, you are bombarded nowadays with ideas and possibilities. In addition to thousands of books, almost every newspaper carries a food column. Color supplements and magazines have articles with mouthwatering illustrations. Television spawns celebrity chefs and hours of programs showing everything from haute cuisine to cooking for survival in the jungle. Somewhere in this plethora, ideas catch your eye and interest you. You buy a book; you download recipes from the Internet; you eat something delicious in a restaurant or at a friend's house. Before long, your books bulge with postcards, old envelopes, and yellowing newspaper cuttings. Likewise it is not surprising that Emma Darwin, wife of the great nineteenth-century biologist, had a notebook of recipes. She was in the great tradition of women who ran what were, by almost any standard, large and complex households, and she was organized enough to write things down. Her sources, like today, were family and friends; published books and articles were plentiful even in the mid-nineteenth century. In 1857, when Isabella Beeton was planning what would become her *Book of Household Management*, a friend wrote urging her to collect recipes from "the best books published on cookery and heaven knows there is a great variety to choose from."[1]

A PAINTING OF EMMA WEDGWOOD BY GEORGE RICHMOND, WHICH WAS COMMISSIONED BY HER FATHER, JOSIAH WEDGWOOD II, 1840.

What is interesting about Emma Darwin's manuscript is the family for whom it was compiled. Emma Wedgwood married her cousin Charles Darwin on January 29, 1839. They were both grandchildren of Josiah Wedgwood, the founder of the famous pottery, and had known each other since childhood. As Darwin wrote, "We are connected by manifold ties."[2] Just before the wedding, he had been elected a Fellow of the Royal Society, an indication of his standing in the scientific community. In the two years since he had returned from his five-year voyage on the *Beagle*, he had worked on his collections of specimens, published several papers, and opened the first of his notebooks on the transmutation of species. This work would come to fruition twenty years later in *On the Origin of Species*, a book that Thomas Henry Huxley, writing in 1887, described as "the most potent instrument for the extension of the realm of natural knowledge which has come to men's hands, since the publication of Newton's *Principia*."[3] The debate that erupted after the appearance of the *Origin* still reverberates today. But what of the woman Charles Darwin married?

Emma, the youngest in her family, was already thirty when she married. She was experienced in running the Wedgwood family home at Maer Hall in Staffordshire, where, with her eldest sister, Elizabeth, she looked after their elderly parents. Her mother, in particular, had been ailing for some years. Historically, Emma has seemed to many an unremarkable figure, a woman who devoted herself entirely to caring for her husband and children. In her excellent and illuminating biography, Edna Healey describes Emma as an inspirational wife to her husband.[4] Her reputation for devotion is entirely justified, but she had much more to her than that. The hundreds of surviving letters build a picture of an intelligent, lively, gifted, and sensitive person with a great sense of fun. By the standards of the age she was well educated—she spoke French, German, and Italian, and was an accomplished pianist. Apart from a year at a London boarding school when she

AN INTERIOR VIEW OF DOWN HOUSE, HOME TO EMMA AND
CHARLES FROM 1842 UNTIL THEIR DEATHS.

was fourteen, her teachers were Elizabeth and visiting tutors. This was a pattern repeated by Emma with her own daughters, who were also educated at home. She came from a brilliant family whose friends included leading political and literary figures and for whom the great controversies of the age—the abolition of slavery, parliamentary reform, and the various revolutions and upheavals in Europe—were the stuff of conversation. So it is surprising, and perhaps disappointing, to find Emma writing in 1888, "The fact is I do not care about the higher education of women, though I ought to."[5] The ghosts of past Wedgwoods must have prompted this twinge of guilt, for the family believed in educating its daughters.

Before marriage, she loved dancing and parties and had traveled frequently to Europe; an aunt of whom she was fond lived in Geneva. Concerts and the theater gave her great pleasure. Emma also had a serious side. She had a strong religious faith and a well developed sense of duty. Describing her in later life, her daughter Henrietta referred to "a certain reserved gravity" and admitted that some found her mother formidable on first

acquaintance.[6] Her manner to young suitors was firm, open, and even discomfiting. Emma had no time for pretentiousness in anyone and could be outspoken and frank, but without malice. The rather grim photographs of the time, with their need for long exposures, robbed their sitters of all spontaneity. Even so, perhaps just a hint of humor is evident in an 1881 picture of Emma, then seventy-three. Her letters confirm a continuing liveliness and interest in things well beyond her immediate family until just before her death.

For Charles Darwin, marriage was not to be undertaken lightly. In 1838, he brought to his own future reproductive life the habits he had acquired as a scientist. On a scrap of blue paper, he famously wrote down the

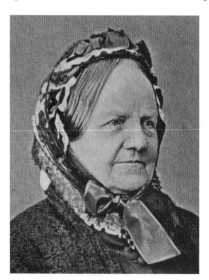

MRS. EMMA DARWIN, CIRCA 1881.

arguments for and against marriage, seemingly without anyone particular in mind. In support of marriage were companionship, "someone to take care of house . . . a nice soft wife on a sofa with good fire, & books & music perhaps." He concludes, "Marry, marry, marry."[7] There is no mention of food, however.

Having come down firmly in favor of marriage, within a few months, he had plucked up courage, proposed, and been accepted on November 11, 1838. Both families were delighted. Emma's brother was already married to Darwin's sister. As Dr. Darwin wrote to Emma's father, "Emma having accepted Charles gives me as great happiness as Jos having married Caroline, and I cannot say more."[8] Both fathers made generous financial settlements on their children, and the young couples were comfortably off.

THE STAFF OF DOWN HOUSE.

The letters that passed between them in the short weeks before the wedding are tender, but also full of fun and busy excitement. Darwin describes hunting for and finding a house in Gower Street in London.[9] They called it Macaw Cottage because of its garish decoration of azure walls and yellow curtains. They experienced some inevitable difficulties in finding reliable servants—"the cook from Shrewsbury [Darwin's home town] is a failure as she cannot cook, and has a drunken husband." Fortunately by January 7, 1839, a more suitable candidate had been found and engaged at 14 guineas per year "with tea and sugar."[10] It is wonderful to visualize Darwin, familiar as the bearded, solemn figure from the later portraits, shopping with his brother Erasmus in the Baker Street bazaar for "coarse furniture" (for the servants), fire irons for their bedroom, and paying "a shop a visit . . . which greatly tempted me [Darwin] to buy lamps, all sorts of nice pots, pans, urns, etc."[11] The cook, incidentally, did not last long; by March, Emma was already looking for another, preferably from the country. Finding good

cooks was a perennial problem, and not only for the Darwins. Years later, Dr. Joseph Hooker, close friend and eminent botanist, wrote plaintively to Darwin about his family's need for a good cook. Could Mrs. Darwin help? He wrote: "Quite a plain cook is all we want, who can roast, boil & bake, but she must be beyond the age of flirtation."[12] Darwin replied: "I wish to Heaven Nat. Selection had produced 'neuters,' who would not flirt or marry."[13]

Despite her happiness, Emma perceived two clouds on the horizon. The less serious is voiced in a letter to her Aunt Jessie. Having rejoiced over Darwin's many virtues and her own delight, she admits that "he has a great dislike of going to the play, so I am afraid we shall have some domestic dissensions on that head."[14] What troubled her more was the matter of religious belief.

Writing in his autobiography, Darwin admitted that, before he had become engaged, his father had advised him to keep his religious doubts to himself, citing the "extreme misery" that could arise when couples disagreed about such matters.[15] However, he was too transparent and Emma was too perceptive for the truth to be concealed. Darwin was never aggressive in his skepticism and, indeed, was conformist in his behavior. All their children were baptized and confirmed in the Church of England. On Emma's part, she set down her feelings on the matter in two long letters to her husband, explaining that she found it easier to write, rather than talk, about such things. The first was written just after her marriage, the other more than twenty years later. In the end, the problem remained: for him there was no evidence and for her it was a question of feeling, not reasoning.

The Darwins stayed in London until 1842. In September, already with two children, they moved to Down House on the North Downs of Kent,

DOWN HOUSE. IN THE MIDDLE OF LABOR RIOTS, DARWIN AND EMMA MOVED FROM LONDON TO THE SUBURBS AND BOUGHT THIS HOME FROM THE REV. JAMES DRUMMOND.

sixteen miles from London but involving a journey that took two hours. This would be their home for the rest of their lives. Darwin described the attractions of the nearby village: the inhabitants were "very respectable" and not only did the village have its grocer, butcher, and baker, but also, "a carrier goes weekly to London and calls anywhere for anything in London, and takes anything anywhere."[16] Eight more children were born at Down House, which needed altering and enlarging more than once to accommodate the growing family and the visits from friends and numerous relations. The Darwins loved children and seem to have had infinite time for them. For their part, children adored life at Down. Henrietta, the fourth child, remembers: "My father took an unusual delight in his babies, and we have all a vivid memory of him as the most inspiriting of playfellows."[17] The Darwins were generous with their hospitality to family and close friends. As an example, they welcomed the seven Huxley children and their two nurse-maids for a fortnight so that their mother could go with her husband to the meeting of the British Association, of which he was then President.

Many of the family went on to write accounts of life there. In *Period Piece*, Gwen Raverat, a Darwin granddaughter, paints a picture of an idyllic life. She knew it only after Darwin's death and when Emma was already an old woman, but the atmosphere would not have altered. "To us, everything at Down was perfect . . . and as soon as the door was opened, we smelt again the unmistakable cool, empty, country smell of the house, and we rushed all over the big, under-furnished rooms in an ecstasy of joy. They reflected the barer way of life of the early nineteenth century, rather than the crowded, fussy mid-Victorian period. The furnishing was ugly in a way, but it was dignified and plain."[18] Emma's housekeeping style was relaxed, and as a girl she had been known as Little Miss Slip-slop. It was too much for Darwin's Shrewsbury family. While on a visit to his father with his son, Darwin wrote, "A thunder storm is preparing to break on your head, and which has already deluged me,"[19] referring to the fact that Bessy, the chil-

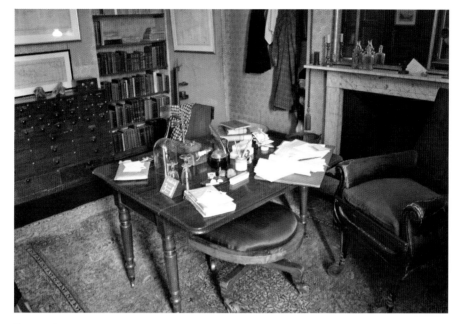

DARWIN'S STUDY, RECENTLY RESTORED TO APPROXIMATE ITS ORIGINAL APPEARANCE.

dren's nurse, did not wear a cap—a laxness unacceptable in the Shrewsbury home. They may not have had the right caps, but at Down the servants were treated with politeness and respect. In return, many gave long service and loyalty. Parslow, the butler for many years, together with the long-serving cook, Mrs. Evans, were in Westminster Abbey with the family at Darwin's funeral. A family story even has Darwin in the kitchen, taking over the cook's hand at whist so she could get on preparing the meal.[20] A degree of flexibility in who did what must have been welcome as Down was not only a home but also Darwin's workplace and laboratory. He held no post in any university or institute—all his work, experiments, and writing was done at Down, and a more tidy and fussy woman than Emma would have been driven to distraction. Emma also allowed the children's untidiness to accumulate until the room became unbearable, and only then did she call in a maid to clear things up.[21]

DARWIN'S GREENHOUSE.

With the growing family of children and servants—of whom there were about a dozen, many of them living at Down—the first of several major alterations to the house and garden began in 1845. Outside there were "great earth-works" and in the house "a schoolroom and one, or possibly two small bedrooms"[22] were created. Darwin was also considerate of his servant's needs. In a letter to his sister Susan, he explains, "The servants complained to me what a nuisance it was to them to have the passage for everything only through the kitchen; again Parslow's pantry is too small to be tidy. It seemed so selfish making the house so luxurious for ourselves and not comfortable for our servants, that I was determined if possible to effect their wishes." For someone who had spent five years on a ship, perhaps he was being a little too forgiving of Parslow's habits. Mindful of his family's frugal instincts, Darwin hoped that the "Shrewsbury conclave will not condemn me for extreme extravagance."[22]

Ill health cast a long shadow over this picture of happy rural life. Volumes have been written about Darwin's mysterious illness. Speculation has been fueled by his own meticulous record of his symptoms. Explanations include everything from the extravagantly psychoanalytical to the suggestion of a rare tropical disease, possibly caught on the *Beagle* voyage. A recent paper makes a case for Crohn's disease,[23] whereas others have stressed psychosomatic aspects.[24] What is certain is that, as one commentator put it, the perfect nurse had married the perfect patient. Gwen Raverat wrote skeptically that "the attitude of the whole Darwin family to sickness was most unwholesome. At Down, ill health was considered normal."[25] This is a little hard. Infant death was common and tuberculosis destroyed whole families. Three of the Darwins' ten children died in infancy or childhood. However, it has to be said that, in spite of constant worries, the survivors lived long (for that era) and, for the most part, had extraordinarily productive lives. Darwin himself salvaged some advantage from his own sickness, writing in his autobiography, "Even ill-health, though it has annihilated several years of my life, has saved me from the distractions of society and amusement."[26]

All this must have seriously affected the eating and cooking in the Darwin household. In the first years of their marriage in London, they held dinner parties, but almost at once Emma was aware that, much as Darwin seemed to enjoy such occasions, they brought on bouts of illness. Drinking wine disagreed with him, "and it is so tiresome not drinking that he can't resist one glass."[27] She obviously enjoyed acting as hostess in her new home and amusingly describes "our learned party" of April 1, 1839, to her sister Elizabeth. Conversation flowed, "notwithstanding those two dead weights, viz., the greatest botanist and the greatest geologist in Europe, we did very well and had no pauses. Mrs. Henslow has a good, loud, sharp voice which was a great comfort, and Mrs. Lyell has a very constant supply of talk."[28] The food at dinner was "very good."

The pattern of meals changed in the course of the nineteenth century, both in timing and in what was eaten. Dining *à la francaise* gradually gave way to *service à la russe*. Broadly speaking, the earlier form of presentation consisted of a succession of dishes laid out on the table; how these were laid out was important. These dishes were then replaced or "removed" by others. This might happen three or four times, depending on the scale of the meal and the number of diners. Early on in the century, it was common to include both savory and sweet dishes in the same course. This gradually changed, with the puddings tending to arrive with the later courses. The guests ate from the dishes within reach, ladies relying on their gentlemen neighbors to help them to their chosen foods. The first couple of pages in Emma's recipe book show basic table plans for arranging dishes *à la fran-*

caise on a table. As the century progressed, this extravagant and impractical system gave way to *service à la russe*, where the table was more elaborately laid with places for each guest and a relatively simpler succession of courses was delivered by servants. Both systems assume that a fair number of people were dining. For what Mrs. Beeton called Plain Family Dinners, the menus are much simpler—mostly two- or three-course affairs that do not look out of place today. As for timing, dinner moved from early afternoon to four or five o'clock, then to six or even later, while lunch moved in to fill the space left in the middle of the day. All these changes were matters of fashion. In London, the newly married Darwins lunched at two o'clock and dined at six. By the time they had been at Down House for several years, lunch, the main meal of the day for all the family, was at one o'clock. These habits were by no means universal, as is noted by Henrietta. When, in 1868 she stayed with her Great Aunt Fanny in Tenby, they dined at five o'clock. Henrietta felt the need for "luncheon of some kind," but Great Aunt Fanny ate "nothing between breakfast and dinner."[29]

Darwin wrote, "During the first part of our residence [at Down House] we went a little into society and received a few friends here, but my health almost always suffered from the excitement, violent shivering and vomiting attacks being thus brought on. I have therefore been compelled for many years to give up all dinner parties and this has been somewhat of a deprivation to me, as such parties always put me in high spirits."[30] Perhaps surprisingly, from what we know of Victorian habits, lunch was taken with the children, even when strangers were present. On one occasion near the end of Darwin's life, Edward Aveling, whose contemporaries vied with each other to describe his ugliness (but who had some magical attraction when it came to women), invited himself to Down House, bringing with him a German guest, Dr. Büchner. Both were in London for the Congress of the International Federation of Freethinkers. Aveling described the lunch in some

detail, though, alas, gave no hint of what was eaten. Emma sat at the head of the table protected from the notorious atheists by the retired vicar from the village. Darwin sat between the two main guests and, as Aveling wrote, "opposite to us were little children."[31] These probably included Bernard, a Darwin grandchild who could not have been more than five. Even in the liberated modern age, few parents would have felt comfortable inflicting such company on their offspring. While it was not a consuming passion, Darwin enjoyed his food. Despite all the ill health, Emma was able to write hopefully, after a bad bout of sickness in 1863, "His good symptoms are losing *no* flesh & having a good appetite so that I fully hope that in time he will regain his usual standard of health which is not saying much."[32] Thanks are sent for baskets of fresh poultry from the country, and Darwin, as always, interested in everything, writes from Shrewsbury to Emma that he has got some recipes for puddings and "some strong effectual hints about jams."[33] Perhaps they were copied into the recipe book.

THE ORIGINAL LABEL ON MRS. EMMA DARWIN'S RECIPE BOOK.

Emma's recipe book is small, about eight inches high, a little less than that in width. The binding is of half leather, with marbled boards and marbled endpapers, the cover much darkened with age and rubbed with use. The paper within is unlined, thick, and smooth. Perhaps the book was intended as a portable sketchbook, the sort a young lady would carry with her on some expedition. On the cover, a label reads: *Mrs. Charles Darwin's Recipe Book, Down.* Inside, in the same hand, a short note is attached explaining that the book was given to H. D. and I. D. (Horace, the Darwins'

fifth son and his wife, Ida) after Bessie's (the fourth Darwin daughter) death in 1926. On the first page is the simple inscription, in a firm graceful hand: "Emma Darwin May 16th 1839." Newly married and in charge of her own house in London, Emma was starting to give dinner parties and was anxious to record advice.

The notebook is a business-like document and little in it is personal; rarely is an opinion given of whether a particular dish is good or especially liked. Clues are provided as to where the recipes came from: Turnips Cresselly and Penally Pudding were obviously from Emma's mother's family home in Wales. The Tollets, the source of a soup recipe, plain biscuits,

and instructions for curing hams, lived at Betley Hall near Emma's home at Maer in Staffordshire. Georgina Tollet, a writer, was a close friend of Emma. (Later she would check the proofs of Darwin's *Origin* for style and spelling.) The long arm of Shrewsbury is also present in the notebook—Mrs. Grice, cook to the Darwin family at The Mount, gave advice on salting bacon and hams and two recipes for sauces. Dr. Joseph Hooker contributed Compote of Apples. Did Darwin particularly like a pudding he had had while staying at a clinic at Moor Park in Surrey? Certainly the Blancmange Moor Park is ideal invalid food, though it could be enriched with egg yolks and so become a custard to "put over stewed fruit." The same question may be asked about Ilkley Pudding, Ilkley being another place with a hydrotherapy establishment visited by Darwin in his search for a cure to his illness.

Very few dates are given, and the entries seem to be in the wrong order. Dr. Hooker's Compote of Apples (July 1844) comes well before salting hams (February 1843). Is it possible that an accumulation of scraps of paper was neatly written up at a later date? Occasionally, another hand is evident—the recipe for boiling rice is in Darwin's own and other hands have been recognized. Annie Darwin copied out the instructions for Italian Vegetable Soup.[34] She was the Darwins' beloved second child, who died, aged ten, in 1851. Making a fair copy may also account for the occasional end to a recipe before the full instructions have been given. This is true of Fondeau or Cheese Soufflé, which breaks off, crucially, before dealing with the egg whites—this soufflé would not have risen! Interestingly, this is a recipe that is almost word for word given by Eliza Acton in her *Modern Cookery for Private Families*, first published in 1845.[35] The recipe for Celery Sauce for Boiled Fowls is also very similar in wording to that given by Mrs. Beeton.[36] We can only speculate how these recipes came to be included. Did Emma

To Boil Rice

Add salt to the water and when boiling hot stir in the rice. Keep it boiling for twelve minutes by the watch, then pour off the water and set the pot on live coals during ten minutes — the rice is then fit for the table / //

eat a really good poached chicken with celery and ask for instructions about how it was cooked? Did the Darwins sit in dentists' waiting rooms supplied with magazines in which she came across one of the monthly publications that first carried Isabella Beeton's recipes?

We do not know how much, if any, cooking Emma did herself, but she had a good working knowledge. One of her first actions in her new London home was to take her cook to task for not boiling potatoes properly. The manuscript has helpful hints—onions should be boiled a little before slicing, scum skimmed off as it rises, and timing should be exact—all indicating that she was familiar with preparing the dishes involved and had noted small details that made the process easier. As for the boiling of rice, the image of Darwin standing over a pot of boiling water with his pocket watch in hand, timing the cooking and drying of rice, is one to treasure.

These recipes are for a family—good plain cooking is a phrase that comes to mind. Very few contain alcohol; the sauce for Plum Pudding and

Nesselrode Pudding are two. Only once does a hint of indulgence appear in the Marie Louise Pudding, an otherwise rather ordinary bread and butter pudding, to which a final tempting comment is added: "What makes it good is to have a good deal of brandy and candied orange peel in the bread." The manuscript is also interesting for what is not there. No instructions are given for boiling a chicken or roasting a joint of lamb or beef. Relatively few recipes include vegetables. From this it is fair to assume that this book is a collection of "extras," ideas that caught Emma's fancy in the same way cooks collect recipes today. The basics of everyday cooking are a "given," known by Emma, or at least by her cook, and not needing to be written down.

The manuscript contains many recipes for puddings. Darwin loved sweets and vowed to himself that he should give them up but excused his failure, claiming that vows were never binding unless made aloud.[37] Certainly, when working through the puddings, we found that we could almost always reduce the amount of sugar. Many puddings are variations on the custard theme, using milk (or cream), eggs, and sugar. This was an era innocent of cholesterol and its perils. Some will find the repeated instruction to boil a pint (or quart) of cream rather shocking but it does make for delicious results. Just do it less often than Emma would have done. Apples, pears, and soft fruits, all of which were in the garden at Down House, are also featured frequently and it is easy to understand the interest in finding something new, a little different, in the way of treating these staples. Some "convenience" foods appear. Curry powder, mushroom ketchup, essence of anchovy, soy, and Universal and Harvey's sauces all make an appearance. By the end of the book, gelatin has replaced isinglass, which must have made life much easier in the jellies and blancmange department.

THIS MODERN-DAY BOTTLE OF MUSHROOM KETCHUP—A CONDIMENT STILL USED TODAY, ALBEIT LESS FREQUENTLY THAN IN DARWINS' TIME—BOASTS A LABEL UNCHANGED SINCE THE NINETEENTH CENTURY.

Round of Beef de Chasse
(Hunters beef)

1 Oz of Salt petre, 1 do of Clove-peppers, half a pound of Salt beat altogether, & rubbed upon the beef, and the liquor well basted upon it every day for a fortnight – If a large round 6 hours will bake it with a little paste. —

Pickling and preserving were important in the nineteenth century, not only to deal with seasonal plenty, but to add interest to food in the leaner months. The very first recipe in the book is for Round of Beef de Chasse or Hunters Beef (see above), which we were all for trying until we discovered that the round of beef suggested for this treatment weighed twenty-five pounds! Meat pickled like this would keep well for several weeks, longer if more salt was used, though the flavor would not be so good. The Darwins kept pigs at Down and instructions are given for curing hams and bacon along with the intriguingly named Archbishop's Leg of Pork. We visited Emmett's Stores in Peasenhall in Suffolk, famous for many years for its hams and bacon, and allowed Mr. Thomas, supplier of hams to the late Queen Mother, to cast an eye over Emma's recipes. He pronounced them perfectly sound. As with the beef, the quantities involved make the home production of hams impractical. For the Darwins, meat was an important

element in their diet. The Down House accounts show that in 1877 more than 70 percent of the budget for food went to meat, bacon, fish, game, and poultry.[38] One can only admire the way in which women like Emma and her cooks tackled such projects along with the day-to-day work of feeding a large household.

When it comes to bottling fruit and making jams and jellies, it is possible and, indeed, very enjoyable to produce your own. Few more satisfying sights can be found than a row of nicely labeled jars of jam and the taste can be far superior to anything bought. Some pickles are much more tricky than others. Emma has a recipe for pickling walnuts and also one for lemons. For walnuts, the instructions only cover making the spiced vinegar that goes in at the end of what is a lengthy process—the nuts must be very unripe, not woody, and they have to be soaked in brine for days before being dried in the sun. You would need Mrs. Beeton's instructions if you want to do all this with any hope of getting a good result. As for the lemon pickle,

the recipe includes an unusual stage where the salted fruit is completely dried out in a low oven before the spiced vinegar is added. Then, hidden in among all the puddings, *crème a la victoire*, stone cream, Italian cream, and burnt cream, is an entry for cold cream and this, it turns out, is not edible but cosmetic! This must have found its way into the wrong notebook. Even so, it was something that we had to try.

It is unknown what kind of cooking range they had at Down. The Darwins were well off, but did consideration for their cook extend to the latest model of the "improved" kitchen ranges praised by Mrs. Beeton? The closed kitchen range with oven, or ovens, and a boiler to heat water, all fueled by coal or coke began to be introduced from the beginning of the nineteenth century, but it was many years before they became universal. The recipe book has instructions calling for cool and hot ovens so it would seem that they had something advanced enough to allow them to control the temperature to some extent. Anything recognizable as a grill has yet to make an appearance. The salamander is mentioned more than once, and to broil mushrooms the instruction is to "set them before the fire to do." When the family went on holiday, often to the sea, it was something of a royal progress. Everyone went—children, nursemaids, and the long-suffering cook, who doubtless had to cope with whatever the rented house had in the way of a kitchen. Although neither Darwin nor Emma seem to have been much interested in their Wedgwood heritage, when it came to dishing up the prepared food, they had, nevertheless, a magnificent dinner service decorated with the "Waterlily" pattern.

Something needs to be said about quantities. Most of the recipes give manageable amounts of ingredients that would feed from four to eight people. Some are on a larger scale, however. Gingerbread is made with two pounds of flour, teacakes with a quarter of a stone (three and a half pounds)—the results would have been big batches, so either they kept well

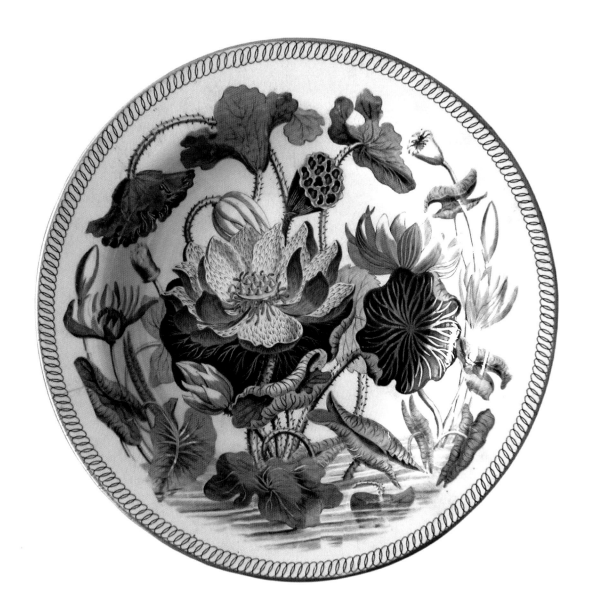

An example of the Wedgewood's "Waterlily" pattern used by the Darwins.

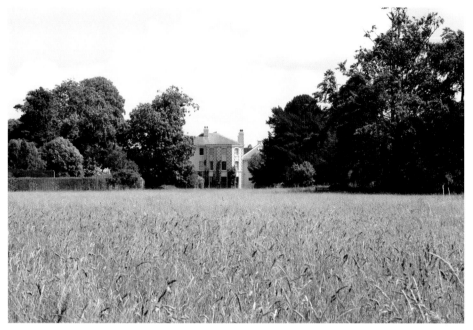

or they were consumed in large quantities. Cheese straws, however, only involve one and a half ounces of flour; even though the pastry is rolled out very thinly, the quantity produced can easily be eaten by four people with a predinner drink. Given that eating the results of our cooking was an important part of the exercise, we halved or otherwise adjusted the quantities to suit the circumstances. We trust the reader will be able to do the same, doubling up or reducing as seems fit.

Finally, it must be said that we have not worked through every recipe in Emma's original notebook, but have selected those that seemed interesting and practical. We had some difficulties. What appeared obvious and straightforward at first often proved puzzling when we assembled the ingre-

dients and started cooking. Nevertheless, we have tried to remain faithful to Emma's book and not stray too far into what would be considered best practice today. When we started working on this project, the general feeling among those who knew the manuscript was that the food would be, at the worst, dire, at best, dull. Given the general Victorian preoccupation with stomachs and delicate digestive systems, only increased by the Darwins' obvious concern in these matters, the food proved very good indeed. We picked up a few interesting tips on the way—pickled walnuts in a sauce for beef and red currant juice in raspberry jam were just two. Certainly we shall make some recipes again with pleasure. Above all, cooking and eating a dish enjoyed by Charles Darwin and his family brought us closer to the great man. And our impression of Emma at the end of our culinary journey? We felt a growing admiration and warmth, and found it was natural to refer to her by her first name. Possibly for different reasons, most biographers of Darwin have done the same. We found no revolutionary insights into Emma's personality among the recipes. She remains somewhat elusive in her notebook. However, it is from her letters that she emerges as a truly interesting and extraordinary woman. We can hardly say better than Darwin himself, that she was "as good as twice refined gold."[39] He wrote, "Think of this my own dearest wife. I wish you knew how I value you; and what an inexpressible blessing it is to have one whom one can always trust, one always the same, always ready to give comfort, sympathy and the best advice. God bless you, my dear, you are too good for me."[40]

—DUSHA BATESON AND WESLIE JANEWAY

Recipes

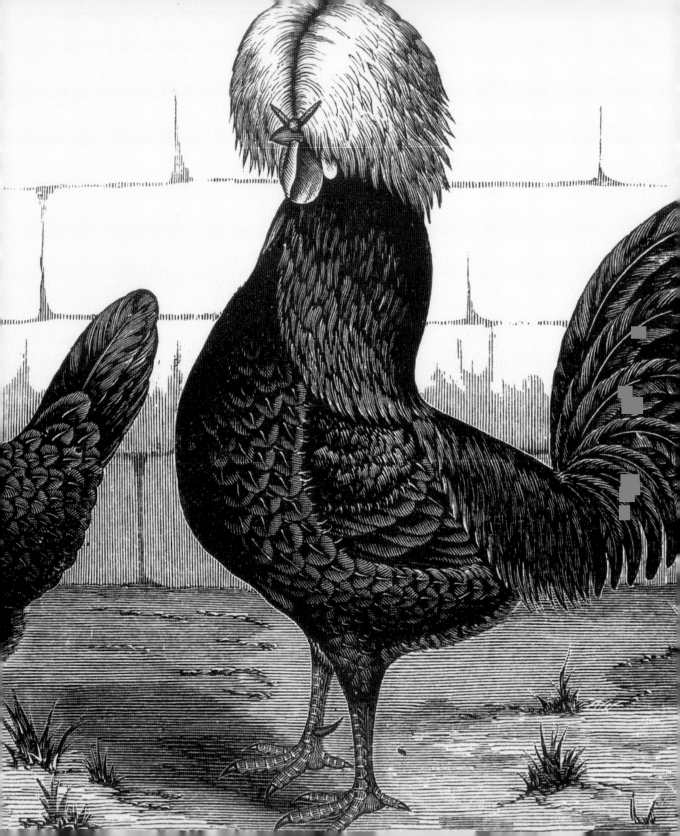

CHEESE AND EGGS

THE DARWINS AT Down House had something of a farmyard, populated with horses, cows, pigs, and poultry. They kept ducks as well as hens, including some exotic varieties, like the Polish fowl shown in the illustration opposite. The poultry was multi-purpose, providing not only meat and eggs for the family but also subjects for Darwin's observations and experiments on variation, heredity, and domestication. While the house was also his workplace and laboratory, the gardens, greenhouse, orchard, and home meadow were the adjacent biological field station. Cooks, gardeners, and children were all, at one time or another, employed as research assistants. Seasonally, milk, eggs, and cream would have been plentiful; they certainly appear frequently in the pudding recipes. From the evidence contained in the notebook, cheese was simply "English" or "Parmesan." Emma has also noted instructions for preserving eggs with limewater (calcium hydroxide). This was one of several methods practiced at the time. It proved reasonably safe and reliable, so much so, that it continued to be used well into the twentieth century.

BUTTERED EGGS

Probably as many methods exist as preferred outcomes for such a simple and well-known dish as scrambled eggs. Some like their eggs well done, with a firmer texture, others favor a creamier, sauce-like result, and there are all points in between. It is the same with boiled eggs—people become passionate about exact timings and outcomes. Perhaps Emma was a supporter of the more creamy scrambled egg. She uses the older name, buttered eggs, with its hint of luxurious richness, while "scrambled" has overtones of haste and carelessness. She also includes cream. As for the final result, much depends on how you interpret her use of the word *rough*. Whatever you prefer, the foolproof way of ensuring you obtain the required consistency is to use a double boiler. It takes longer and so you have a better chance of judging the precise moment when perfection has been reached. Emma's way of first heating the butter and cream together also helps to achieve an excellent, creamy result.

BUTTERED EGGS, A DELECTABLE DISH FOR THE DARWINS' TIME.

46

For each egg, allow ¼ ounce (5 g) of butter
and one tablespoon of heavy cream
Salt and pepper

1. In a bowl, beat the eggs until well blended. Season with salt and pepper.

2. In a heavy pan (or double boiler), heat the butter and cream over gentle heat until the butter has melted and the mixture begins to bubble.

3. Pour in the beaten eggs and, stirring gently, cook until you have the consistency you like.

4. Serve at once on slices of buttered toast.

NOTE: Looking into when "buttered" became "scrambled" revealed that the former also refers to a method of preserving eggs for use in the winter months when hens go "off lay." The new-laid egg is coated in butter while still warm. As the egg cools, the butter, having been absorbed into the porous shell, solidifies and forms an airtight barrier. Carefully stored, these eggs keep for several months!

CHEESE STRAWS

For many of us, the invention of the food processor has turned pastry making from a lottery into a certainty. All those wise saws about cool hands and light fingers can be consigned to the past. Just whiz the flour and butter, add whatever liquid the recipe calls for—milk, water, eggs, whole or yolks—another quick whirl and the job is done. Having said that, the original amounts given for Emma's cheese straws added up to just about the minimum volume with which an ordinary processor can function properly. If you have a machine with a large capacity, you could double the quantities here or fall back on the cool hands and light-fingered method. Doubling the quantities will give you a lot of cheese straws. One last word of advice, it is important to use Parmesan, or a cheese similarly dry, and not just any hard cheese, which may liquefy on baking. Makes about forty cheese straws.

> 1½ ounces (40 g) Parmesan, finely grated
> 1½ ounces (40 g) plain flour
> ¾ ounce (20 g) butter cut in small cubes
> A pinch of cayenne pepper
> A little salt
> Milk

A PERFECT SNACK THAT DRESSES UP ANY TABLEWARE, THESE STRAWS CAN BE SERVED BOTH FORMALLY AND INFORMALLY.

IN PREPARATION: Preheat oven to 325°F (160°C).

1. Whiz the first five ingredients in a food processor until nicely blended.

2. Add enough milk, so that with the machine running slowly, the pastry shows signs of coming together.

3. Pour the mixture onto a floured surface and knead quickly into a ball.

4. Roll out the pastry until it is very thin.

5. Cut into strips—about ¼ inch (0.5 cm) wide and 3 inches (8 cm) long. Place on a baking sheet and cook for about 20 minutes or until golden brown.

6. Carefully transfer onto a wire rack and leave to cool. They will become crisp and easier to handle as they cool. Store in an airtight tin.

BAKED CHEESE CUSTARD
(*Fondeau*)

Baked Cheese Custard: Emma has two recipes with her pseudo-French title. The first is this cheese custard, which might seem strange, but turns out surprisingly tasty. Baked in a small ovenproof dish and served with good bread and a green salad enlivened with rocket or watercress, this Baked Cheese Custard would make an excellent lunch or supper dish. Baked in individual ramekins, perhaps with a sprinkling of breadcrumbs and Parmesan, you'd have a good first course for dinner. Use a strong cheese such as aged Cheddar, or even a blue cheese—Stilton would be good—to give a nice flavor. Serves two.

> 1 ounce (30 g) butter
> 1 ounce (30 g) flour
> 1 cup (250 ml) milk
> 2 ounces (50 g) grated cheese
> 2 eggs, lightly beaten
> Salt and pepper (a little mustard and/or
> grated nutmeg would be good, too)

IN PREPARATION: Preheat oven to 325°F (160°C) and grease a 3-cup (750 ml) ovenproof dish.

1. Melt the butter in a pan over medium heat and stir in the flour. Cook for 3-4 minutes.

2. Add the milk, a little at a time, stirring well to get a smooth sauce. Bring to a boil and let it bubble gently for a couple of minutes. Turn the heat to low.

3. Add the mustard and/or the nutmeg if you are using them.

4. Stir in the cheese and as soon as it shows signs of melting, turn off the heat.

5. Add the eggs and mix well. Season with pepper and salt.

6. Pour into the prepared dish and bake for 20-25 minutes.

CHEESE SOUFFLÉ
(*Fondeau or Cheese Soufflé*)

A well-risen cheese soufflé makes an impressive start to a dinner party, even today. With the ovens available in the nineteenth century, soufflés must have been among the more difficult of dishes to produce. Here we have a lovely example of a recipe passing from cook to cook as has happened since cooking began. When copied, improvements are made but also small mistakes occur from time to time—a model of an evolutionary process one might say. Eliza Acton described the recipe for the Cheese Soufflé as follows:

"Mix to a smooth batter, with a quarter of a pint of new milk, two ounces of potato-flour, arrow-root, or *tous les mois*; pour boiling to them three quarters of a pint more of milk, or of cream in preference: stir them well together, and then throw in two ounces of butter cut small. When this is melted, and well-beaten into the mixture, add the well-whisked yolks of four large or of five small eggs, half a teaspoon of salt, something less of cayenne, and three ounces of lightly-grated cheese, Parmesan or English . . . "

Emma's recipe is too similar to the earlier Eliza Acton version to be a coincidence, but the copying was evidently interrupted and her recipe was unfinished. Did it matter that the final instructions are missing? Perhaps the cook knew enough about soufflés not to need them.

We have used less milk than Emma, as it is important to keep the volume of sauce at somewhere between one-third and one-half that of the egg whites. Serves two as a main course or three to four as a starter.

2 ounces (50 g) butter
2 ounces (50 g) flour
1 cup (250 ml) of milk
2 ounces (50 g) aged Cheddar, or similar strong cheese, grated
1 ounce (30 g) Parmesan, grated
4 eggs, separated (plus 1 or 2 extra whites, if you wish)
Breadcrumbs
Salt and cayenne pepper

IN PREPARATION: Preheat oven to 400°F (200°C).

1. Butter a 4-cup (1-L) soufflé dish and line it with dry breadcrumbs.

2. Melt the butter in a saucepan over medium heat. Add the flour and stir for a couple of minutes.

3. Add the milk gradually and, stirring all the time, bring the mixture to a boil. Let bubble gently for 2-3 minutes.

4. Add the grated cheeses, give the mixture a stir, and turn off the heat, then beat in the egg yolks, one at a time. Season with a little salt and cayenne pepper.

5. Whisk the egg whites until stiff and fold one tablespoon into the cheese sauce to loosen it. Then fold in the rest of the whites, using a large metal spoon. Try to keep as much air in the mixture as possible as this will make the soufflé rise.

6. Pour the mixture into the prepared dish and bake in the preheated oven for about 25 minutes, or until the soufflé is golden brown and beautifully risen. Serve at once.

A fondeau or Cheese Soufflé

Mix to a smooth batter with a quarter of a
pint of new milk - two ounces of potato -
flour or arrow root. pour boiling to them three
quarters of a pint more of milk or of Cream
in preference. ~~of milk or of Cream~~ Stir them
well together and then throw in 2 ounces of
Butter, cut in small pieces, when this is melted
and well beaten in to the mixture; add the
well beaten yolks of 4 eggs, ½ a teaspoonful
of Salt, a little less of Cayenne and 3 ounces
of tightly grated parmesan or English Cheese

SCOTCH WOODCOCK

Nowadays the only place you are likely to come across a savory course is in the dining room of a gentleman's club or at the high table of an Oxbridge College. However, they are often delicious and make excellent dishes for a snack, lunch, or supper. The idea that it was "an aid to digestion" to finish a grand dinner with a final course, often rich in cheese and cream, seems far-fetched. True, the portions would probably be small, but the real attraction may well have been the opportunity it gave to broach another good bottle! These savories, as they came to be known, were common at Victorian and Edwardian dinners—occasions famous for gargantuan excess. They had exotic and fanciful names; angels on horseback (oysters wrapped in bacon) is one of the best known. Welsh rabbit and Scotch woodcock were two more, neither of which involved rabbit or woodcock. The sauce for this is best made in a double boiler. There is no flour here, so the risk of curdling is great. Serves two.

> 2 slices of bread, white or whole wheat
> ½ ounce (15 g) butter, plus a little more for buttering
> Anchovy paste
> ½ cup (125 ml) heavy cream
> 2 egg yolks
> Pinch of cayenne pepper

1. Toast the bread and butter it sparingly. Spread thinly with anchovy paste and keep warm.

2. Place butter and cream in a double boiler and stir until the butter is melted.

3. Add the egg yolks and cook, stirring all the time, until the sauce has thickened and is the consistency of thick custard. Season with cayenne pepper.

4. Place each piece of toast on a warm plate, cut it into quarters, and pour the sauce over it. Serve at once.

FISH

FISH MUST HAVE been a difficult food to manage in Emma's time. The local village had only a few basic shops. Anything out of the ordinary in the way of shopping would have had to come from Bromley, five miles away. However, the notebook has two recipes for fish, as well as instructions for a simple cream sauce intended for fish. At the end of this third recipe, Emma gives some advice: "Boil fish with a good lump of alum in the water." We have to admit that, so far, we have failed to find a satisfactory and authoritative explanation for this. Alum, aluminium sulfate, has had, and still has, any number of uses in various manufacturing processes, including dyeing, printing, and pickling, which at least has something to do with food. Alum has a sweet, astringent taste; possibly it was used to mask any unpleasant taste or smell if the fish was less than fresh. Another suggestion is that it kept the fish white or prevented it from breaking up during cooking.

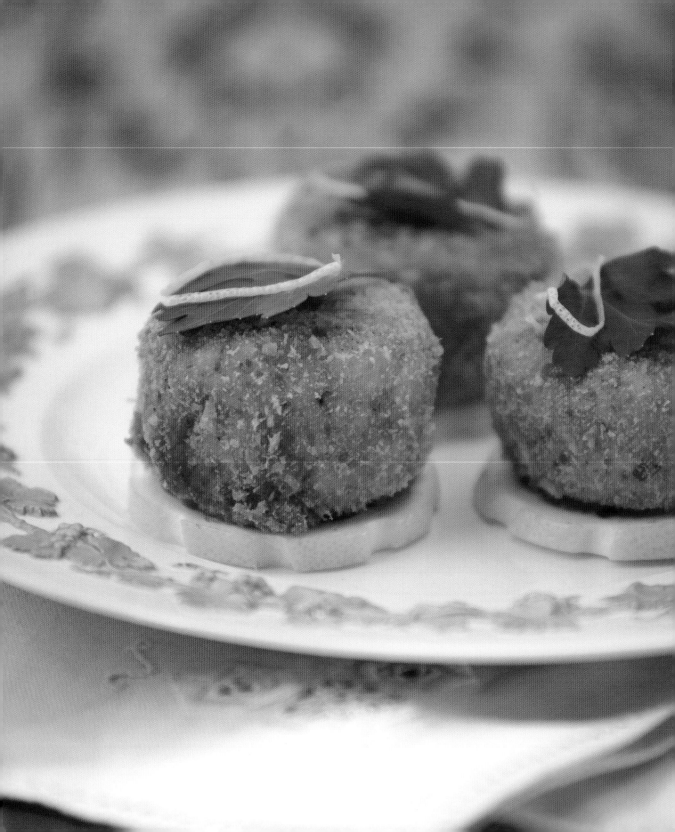

FISH CROQUETTES
(Fish Croquets)

Both of Emma's fish recipes have a frugal air. Were they for leftovers? This one for fish cakes does not include potato, which is added in most modern recipes. Instead, the fish is bound with a little white sauce, making the cakes lighter, a delicious mixture of crisp coating and creamy inside. The sauce has to be thick enough to hold them together; the addition of an egg yolk helps. Even so, you need to take care when frying that they do not fall apart. Many different kinds of fish can be used, but here, lacking any leftovers, the mixture we used was of smoked haddock and fresh cod. These should be poached in a little milk together with some parsley, a sprig of thyme, and a bay leaf. The cooking liquor is kept to make the sauce. Makes eight to ten croquetts.

1 pound (450 g) cooked fish, chilled
1 ounce (30 g) butter
1 ounce (30 g) flour
½ cup (125 ml) milk from cooking the fish
1 tablespoon cream
1 egg yolk
Salt and pepper
1 egg, beaten and breadcrumbs for coating
Butter for frying

FISH CROQUETTES ARE THE PERFECT FOOD TO "DRESS UP" WITH AN ARRAY OF COLORFUL GARNISHES, LIKE SLICES OF LEMON, PICTURED HERE.

1. Flake the fish into a bowl, being careful to remove any skin and bones.

2. Melt the butter in a saucepan and stir in the flour, cook for 1-2 minutes.

3. Add enough of the reserved cooking liquid, stirring constantly to make a thick smooth sauce. Let it bubble gently for a few minutes. Add the cream.

4. Add the egg yolk, give the sauce a quick stir, and remove the pan from the heat.

5. Stir the fish into the sauce and mix gently to combine the two without breaking up the flakes of fish too much. The mixture should be fairly stiff; it will become more so as it cools. Let it get cold.

6. When ready to cook, take spoonfuls about the size of an egg and dip them in the beaten egg, then into the breadcrumbs. Flatten them slightly and fry gently in butter for 8-10 minutes, turning them once. They are done when crisp and golden on the outside and well heated through.

FISH OVERLAY

This is a recipe for using up "the remains of cold fish and sauce." This could be anything from the most humble of fish-pie mixtures to a luxurious blend of lobster with a sauce rich in egg yolks, cream, and brandy. The fishy world is your oyster! Luxury was probably not what Emma had in mind, so here is a simple but delicious sauce to use with whatever fish or combination of fish you choose—cod, haddock, monkfish, turbot. You can add an extra dimension in flavor, if you like, with some smoked fish or prawns. Serves three to four.

> **For the fish:**
> **1½ pounds (700 g) fish, cut into chunks**
> **Salt and pepper**
> **1 cup (250 ml) dry white wine**
> **Sprig of thyme, some fresh parsley, and a bay leaf**

IN PREPARATION: Preheat oven to 400°F (200°C).

1. Season the fish with salt and pepper and place in a shallow pan with a lid.

2. Pour in the wine and enough water to come about halfway up the pieces of fish. Tuck in the herbs, cover, and bring to a boil. Simmer very gently for a couple of minutes, turn off the heat, and let the fish cook for a few more minutes in the liquid.

3. Strain, reserving the stock. Transfer the pieces of fish to an oven-proof dish and keep warm while you make the sauce. If you are using any cooked shellfish, add them to the dish now.

 For the sauce:
 1½ ounces (40 g) butter
 1 tablespoon flour
 1 cup (250 ml) fish stock
 1 cup (250 ml) heavy cream
 2 ounces (50 g) grated Cheddar, Gruyere, or Lancashire cheese
 Fresh breadcrumbs and butter for the topping

1. Melt the butter in a small saucepan, stir in the flour, and cook gently for 2-3 minutes.

2. Slowly stir in the stock, bring to a boil, and let bubble for 2-3 minutes.

3. Add the cream. Let simmer and thicken a little.

4. Add the grated cheese and stir until it melts into the sauce. Check the seasoning and adjust to taste.

5. Remove from the heat and pour over the fish. Give the dish a gentle shake to ensure the fish and sauce are well combined.

6. Cover the surface with a generous layer of fresh breadcrumbs
 and dot with small pieces of butter. Bake for 10 minutes or until
 the top is crisp and golden with sauce bubbling around the edges.

NOTE: In this dish, Emma's original directions for alternating layers of
fish with breadcrumbs seems unnecessary. Possibly if her sauce was thin,
the crumbs would have soaked up any surplus liquid or they might have
served to bulk up the dish if there was not enough fish. For whatever rea-
son, the result would have been rather more stodgy. Keep the breadcrumbs
for the topping.

MEAT

PROBABLY MOST MEAT was plainly cooked in the Darwin household—baked, boiled, or roasted. Meat certainly played an important part in the Down House diet and budget. Emma's notebook has recipes for beef, veal, mutton, and chicken and includes instructions for curing hams and bacon from their own pigs. Pork was forbidden by his doctors, but Darwin shared that common human failing of being unable to resist a little bacon with his breakfast. Famously, when a pig is slaughtered, every scrap of the beast can be eaten in one form or another. The book includes instructions for making brawn which begin: "Cut up the pig's head & cut off the ears, tongue and cheeks"—not for the faint-hearted cook! Game is not mentioned, but features in the household accounts. Darwin had been a keen shot when young, going to sleep with his boots and gun by his bed, the better to make an early start. The nearest we get to any game being eaten at Down is a family story about a pigeon pie being luckily at hand when unexpected guests arrived.

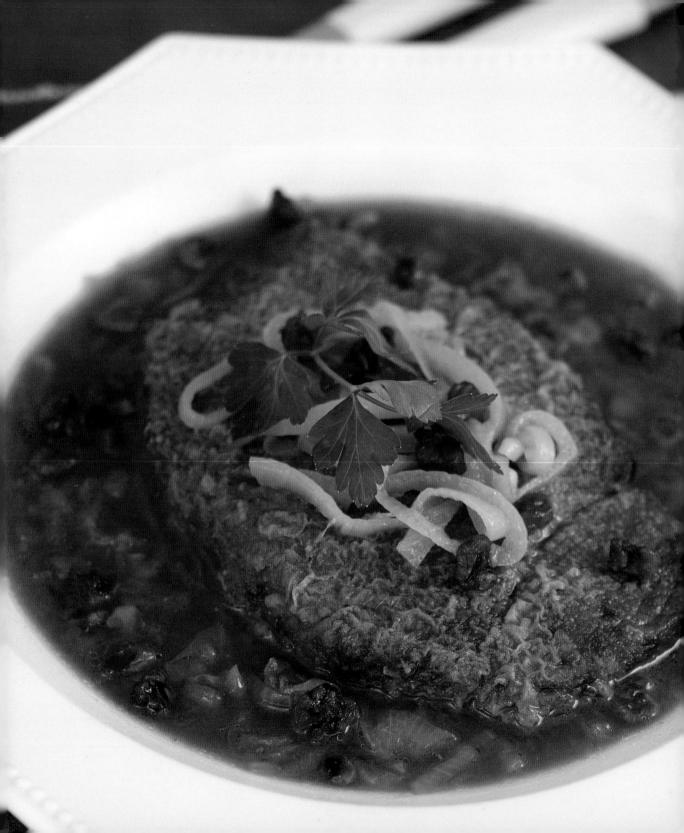

BEEF COLLOPS

For this dish, we have assumed that a collop is a slice of beef, about half an inch thick, cut, as Emma writes, from the rump. Not so thick as for a steak nor as thin as you would use for beef olives. That said, the method seems ordinary—apart from the soy sauce and pickled walnuts. They add a touch of exoticism. At first sight, the use of what might seem unlikely ingredients to add zest and interest to stews and braises is surprising. Nevertheless, it has a long history. The Romans had a sauce made from fermented fish to spice up their meat. Indeed, anchovies are often used *sotto voce* in this way, along with vinegar, chilies, and commercially produced offerings, like various ketchups and Worcestershire sauce. Here we have pickled walnuts and soy sauce. Elsewhere in the manuscript, Emma has a recipe for pickling walnuts, but it is quite a business. Unless you feel passionately, buy them ready-made! As for the soy sauce, you might be forgiven for thinking of this as a modern addition, arriving with Chinese restaurants and takeouts. In fact, it has been a popular import since the seventeenth century. One last thought: It seems a shame that Emma originally wanted to boil the onions. Perhaps it saves time, but the taste will surely be better if they are slowly cooked in a little butter until reduced to a soft, mellow sweetness as we have done here. Serves two to four.

> 2 slices of rump steak, about ½ inch (1.25 cm) thick,
> weighing in at 2 pounds (900 g)
> Salt, pepper, and ground mace
> 2 teaspoons flour

UNDOUBTEDLY, THESE BEEF COLLOPS MAKE A SUMPTUOUS COMPANION DISH TO MASHED POTATOES.

Butter for frying, plus more for greasing
4 onions, sliced thinly
1 cup (250 ml) chicken or beef stock
2 pickled walnuts
1 tablespoon of soy sauce

IN PREPARATION: Preheat oven to 300° F (150° C). You will need an ovenproof dish with a lid. A shallow cast iron one is ideal.

1. Mix salt, pepper, and ground mace with the flour and sprinkle over the meat.

2. Melt the butter and fry the meat gently for 2-3 minutes, turning the slices once. Take them out of the pan and set aside.

3. Add the onions to the pan and cook over a low heat until soft and golden and just beginning to brown. This can take up to 30 minutes or even longer depending on how much moisture they contain.

4. Stir in the stock. Lay the collops on top of the onions.

5. Cover with a well-buttered piece of greaseproof paper and put on the lid. Bake until the meat is very tender—about 1-1½ hours.

6. About 20 minutes before serving, chop and mash the pickled walnuts and add them with the soy sauce to the meat, taking care not to break up the collops. Serve very hot.

CHICKEN AND MACARONI

Mrs. Beeton manages to sound both suspicious and disapproving of macaroni when she describes it as a paste "to which, by a peculiar process, a tubular or pipe form is given." Nevertheless, by the mid-nineteenth century, macaroni with cheese was a popular dish, and the pasta was also being used in sweet dishes. This recipe is an adventurous one for Emma, an early version of the many "pasta bakes" so popular today. If you have leftover roast chicken, this is a good way to use it up. Strip off the meat, cut into bite-size pieces, and use the skin and bones to make stock. Otherwise you will have to start with poaching your chicken. Serves four generously.

> 1 small chicken, preferably free-range
> Vegetables for stock: onion, carrot, and celery
> A few sprigs of thyme and parsley and a bay leaf
> 2–3 tablespoons vegetable oil or butter
>
> To finish the dish:
> 8 ounces (225 g) macaroni
> 1 tablespoon *beurre manié* (equal parts of flour
> and butter mashed together), used to thicken the sauce
> Salt and pepper

1. In a heavy casserole, brown the chicken over medium heat, turning it about in the oil.

2. Remove the chicken and put it aside. Put the chopped vegetables into the pot and cook them until they start to brown on the edges. Put the chicken back in the pot on top of the vegetables, tuck in the herbs, and pour in enough water to almost cover the chicken. Bring to a boil and simmer for about 45 minutes.

3. Turn off the heat and leave the chicken to cool in the stock— overnight is fine.

4. Strip the meat from the bird and reserve. Put the skin and bones back into the stock and simmer for a further 45 minutes. Strain the stock and discard the vegetables and bones.

5. Heat oven to 350°F (175°C). Bring the stock to a boil and cook the macaroni in it until just tender. Drain the pasta but keep the stock.

6. Cover the base of a greased ovenproof dish with half of the cooked macaroni. Place the chicken pieces on top and cover them with the remaining half of the macaroni.

7. Reduce, if necessary, the reserved stock to about 2 cups (500 ml) by boiling rapidly. Lower the heat to a simmer. If it seems too thin and watery (the starch from the macaroni will have thickened it a little), add small pieces of the *beurre manié*, stirring the sauce, until it has the consistency of cream.

8. Season the sauce to taste and pour over the macaroni. Bake in oven for about 45 minutes. If desired, spread some buttered breadcrumbs on the top or a little grated Parmesan.

CURRY

Experience suggests that this dish would be better if made with raw chicken and the curry sauce assembled around it—the whole then being cooked together, rather than, as Emma does, first boiling the chicken and then adding it to the sauce. The next question is, of course, what curry powder did she use? Both Mrs. Beeton and Eliza Acton give instructions for making up your own, but the latter admits that "the preparing is rather a troublesome process," and commercially produced blends of spices were certainly available by the beginning of the nineteenth century. Today, any good supermarket will have all the necessary ingredients as well as a generous choice of mild, medium, and hot blends ready to use. Indian food is so popular that the turnover is rapid and the days when the dusty little tins on the grocer's shelf might have been there for months, if not years, are certainly past! If you like curries, it is fun to experiment. An electric coffee grinder is useful but don't use it for anything else, certainly not coffee. Our adaptation for the recipe given here is very basic. Serves three to four.

For the curry powder:
1 tablespoon ground coriander seeds
1 teaspoon ground cumin seeds
½ teaspoon turmeric
½ teaspoon ground cloves
1 teaspoon chili powder (mild or hot or
 use a fresh chili, finely chopped)

For the chicken:
1½ pounds (700 g) chicken pieces
Oil for frying
2 carrots
1 onion
A few sprigs of parsley and thyme
2 bay leaves

For the sauce:
2 onions, chopped
1-inch (2.5-cm) piece fresh ginger, finely chopped
1 tablespoon of curry powder
2 tablespoons oil for frying
½ tablespoon flour
Salt
A little grated lemon rind and a squeeze of juice

IN PREPARATION: Combine all curry powder ingredients, except fresh chili, if using. Set aside.

1. In a large, deep skillet, fry the chicken pieces in the oil until they are lightly browned.

2. Add the vegetables and herbs and enough water or stock to come about halfway up the chicken.

3. Bring to the boil. Cover the pan and simmer gently for 30 minutes. Allow to cool.

4. Remove the chicken and strip the meat from the bones.

5. If you have more stock than you need—about 1½ cups (275 ml) —boil rapidly to reduce. Strain and discard the vegetables. Reserve stock.

6. Fry the onions in the oil until soft.

7. Add the ginger and fresh chili, if using. Continue to cook gently for 5 minutes.

8. Add the curry powder (a good tablespoon if using ready-made). Keep stirring, being careful not to burn.

9. Add the flour and cook for a couple of minutes.

10. Pour in the stock, stirring all the time. Bring to a boil and let bubble gently for 10 minutes.

11. Add the chicken to the sauce, check the seasoning, and add salt, if needed. Continue cooking for a further 10-15 minutes until it is thoroughly heated through. Add the lemon rind and a squeeze of juice.

12. Serve very hot with rice.

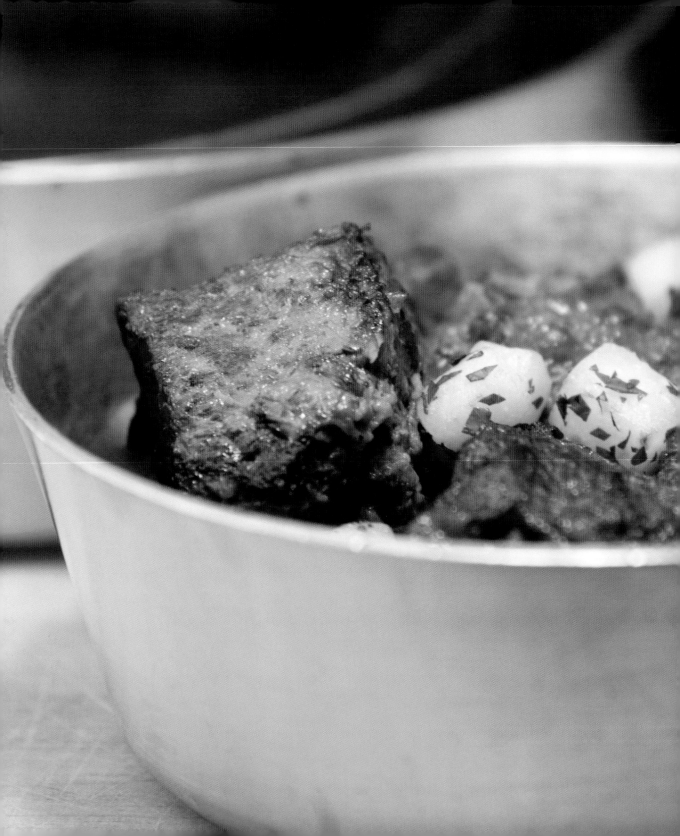

FRENCH RAGOUT OF MUTTON

A marriage between turnips and mutton does not, at first sight, appear to be the prelude to a culinary triumph. However, our present-day version of this recipe proved unexpectedly good. This is food for cold weather. True mutton, meat from a sheep at least a year old, having almost disappeared from butchers, is staging a comeback, following the efforts of some enterprising cooks and enthusiastic reports from food writers. Here, lamb was used as it is, for the moment, more widely available than mutton. If you make this dish in late autumn or in winter, at least the lamb will be a little older and more strongly flavored, than the babies on sale at Easter and in the summer. It will also be the right time for new season's turnips. Serves three to four.

For the ragout:
½ tablespoon flour
Salt and pepper
1½ pounds (700 g) lamb chump (the hind end of the loin),
 boned, fat trimmed, and cut into generous pieces
1 teaspoon sugar
1 cup (250 ml) water or stock
Butter for frying
1 sprig parsley, chopped

For the turnips:
1 pound (450 g) young turnips, peeled and
 cut into ½ inch (1.25 cm) dice
Butter for frying

ON A CHILLY WINTER'S NIGHT, THIS DISH IS A RARE TREAT.

IN PREPARATION: Preheat oven to 325° F (160° C).

1. Season the flour with salt and pepper and place in a plastic bag with the pieces of lamb. Holding the bag closed, give it a good shake so the meat gets coated with the flour.

2. Melt the butter in an ovenproof dish with a lid. Add the lamb and fry over medium heat, turning the pieces so they get evenly browned.

3. Pour in the water or stock and stir, making sure any sticky bits from the bottom of the pan are brought into the sauce. Bring to a boil, add the sugar lump, and simmer for 1-2 minutes.

4. Put on the lid and bake for about 40 minutes. Test the meat with a knife to see if is tender. If not, give it another 10-15 minutes.

5. Taste and add more salt and pepper, if needed. Sprinkle generously with chopped parsley.

6. About 20 minutes before serving, melt a good lump of butter in a large frying pan. Add the diced turnips in a single layer and fry them over medium heat, moving and turning them about so they brown but do not burn. Season with a little salt and pepper and serve with the lamb. Though this is a very basic way of cooking turnips, it is surprisingly good!

VEAL BÉCHAMEL
(*Veal Bêchmele*)

Ask the butcher to cut you thin slices of veal from the loin. Keeping the beating with a rolling pin to a minimum will result in a more succulent escalope. Serves four.

> 4 slices of veal—about 1½ pounds (700 g) in total
> Salt, pepper, and cayenne, to taste
> Butter for frying
> 1 small onion, very finely chopped
> 1 teaspoon flour
> ½ cup (125 ml) heavy cream
> A squeeze of lemon juice and a few slices of
> lemon for decoration

1. Season the veal and fry in butter over moderate heat for 8-10 minutes, turning once. Remove the meat to a serving dish and keep warm.

2. Add the onion to the pan and cook until soft and beginning to brown. Stir in the flour and continue cooking for 1-2 minutes.

3. Pour in the cream and let it thicken and bubble for 2-3 minutes. Check the seasoning. Add a squeeze of lemon juice.

4. Pour the sauce over the meat, decorate with a few lemon slices, and serve.

VEAL CAKE

Emma's original recipe calls for some initiative on the part of the interpreter. Veal cake is what we would probably call a terrine, which in itself is a container filled with chopped, mixed raw meats, often including liver. In addition, we would expect herbs, something fatty (bacon perhaps) to provide succulence, and finally, something to bind the whole thing together. Very often this last would be eggs, perhaps laced with a little brandy. Then all would be baked, pressed, and cooled, which is where you would rejoin Emma. However, she used cooked (boiled) veal and made no mention of anything, apart from bones baked on top, the juices from which would hold her cake together. A few preliminaries will be necessary if you are going to provide the jelly "that hangs round the cake."

Our butcher does not deal in veal in the way he does with beef, lamb, and pork. Presumably this is largely because modern Britain does not value veal in the same way as our continental neighbors do, but also in part as a protest against the barbaric way in which most veal calves have been reared. A special order produced the necessary meat. A splendid piece of fillet of veal duly arrived. It weighed almost four pounds, much more than needed for the cake. In addition, a supply of pork bones and a couple of pigs' trotters will go to make a good strong stock. Serves up to eight.

As one of Emma's most complex recipes, the Veal Cake is also one of the most unusually delicious.

For the veal and stock:
1 veal fillet, about 4 pounds (1.8 kg)
1½ pound (700 g) pork bones
2 pig trotters
2 onions, 2 carrots, 2 stalks of celery, and
 a medium-sized leek, all roughly chopped
A few sprigs each of parsley and thyme
2 bay leaves
1 cup (250 ml) white wine

IN PREPARATION: Preheat oven to 400° F (200° C).

1. Place the bones, trotters, and vegetables in a roasting pan. Tuck in the herbs and roast for 30 minutes.

2. Remove and pour in the white wine. Place the meat on top of the bones and vegetables and add enough water to more or less submerge them but not so much that the meat sits in the liquid. This is a compromise: The veal will steam/roast, rather than boil.

3. Raise the oven temperature to 425°F (220°C) and cook for 20 minutes. Then lower the temperature to 325°F (160°C) and continue cooking for 1 hour. Remove from the oven and put the meat to rest for 20 minutes in a warm place. (At this point, if you have timed it cleverly, two of you, at least, can have a delicious supper of roast veal).

4. Let the meat get quite cool, cover, and refrigerate.

5. Pour the contents of the roasting pan into a saucepan, scraping off any caramelized bits. Depending on how much liquid you have, add enough water to cover the bones and vegetables. Bring to a boil and simmer gently for 2-3 hours.

6. Strain the stock and leave to cool. Refrigerate overnight.

7. The next day remove any fat that has solidified on the surface. You will be left with a wonderful stiff jelly.

> For the cake:
> Cooked veal, thinly sliced
> ½ pound (225 g) lean ham, thinly sliced
> 3 hard-boiled eggs, thinly sliced
> 2 tablespoons finely chopped parsley
> Salt, pepper, and nutmeg
> Reserved stock

IN PREPARATION: Preheat oven to 325° F (160° C).

1. Grease a 4-cup (1-L) ovenproof dish with a lid. Put in a layer of veal slices, followed by the ham, slices of egg, and parsley. Repeat, seasoning as you go, until all is used up, finishing with a layer of veal.

2. Heat the reserved stock until it dissolves and check the seasoning. Pour in enough stock to cover the contents of the dish. Cover with buttered parchment, put on the lid, and place the dish in a roasting pan with 1 inch (2.5 cm) of hot water. Bake 50 minutes.

3. Remove the dish from the pan, place a weight on top of the cake, and cool. The easiest way to do this is to turn the lid upside down on the buttered paper and place a heavy object on it. Leave it like this for about 1 hour, remove the weight, put the lid back on the right way up, and refrigerate. The idea is to press it just enough to hold it all together but not so much that you squeeze all the juices out of the cake.

4. Leave for a day or two. Serve turned out or not with bread, salad, and some gherkins, or, possibly, a pickled walnut or two.

VEGETABLES, SOUPS, AND SALAD DRESSINGS

"TWO DISHES ARE settled for our first dinner—namely soup and asparagus," Darwin joked to Emma in a letter written just days before their wedding. An old Cambridge friend had sent him a piece of silver as a wedding present. Knowing Darwin's passion for bugs and beetles, he had teasingly described it as a *Forficula*, the scientific name for an earwig. Until enlightened by his brother, Erasmus, Darwin seems not to have recognized the culinary earwig for what it was: an implement for serving asparagus. Although no recipes for asparagus appear in Emma's book, several straightforward soups are included, along with dishes using turnips, celery and spinach. The vegetables were always plainly cooked.

For Emma the organization of cooking and feeding her large household was a duty mastered because she had to. However, she loved and enjoyed her garden, taking a keen interest in its planning and planting. Henrietta, her daughter, remembers that, true to her mother's character, the flowerbeds "were often untidy but had a particularly gay and varied effect."

BROILED MUSHROOMS

Fortunately, we have the benefit of modern stoves and broiling or grilling is no problem. Emma's recipe is very simple—mushrooms with breadcrumbs and parsley. Presumably, they were intended as one dish among several at a meal. If you would like to have them on their own, you can add chopped bacon, cheese, or whatever you like to the breadcrumbs. Serves four as a side dish.

> 2 ounces (50 g) butter
> 6–8 large mushrooms, about 1 pound (450 g)
> Salt and pepper
> 4 tablespoons breadcrumbs
> 1 teaspoon chopped parsley

1. Preheat broiler. Melt half of the butter in a shallow roasting pan. If the mushrooms are nice and plump, things can be speeded up by placing them under a moderate heat, gill-side down for 5 minutes. (If mushrooms are thinner, skip this step.)

2. Turn the mushrooms over and place a small piece of butter on each. Season them with a little salt and pepper. Broil for 5 minutes.

3. Sprinkle half a tablespoon of breadcrumbs mixed with chopped parsley on each mushroom, top with another bit of butter, and broil again until the crumbs are crisp and brown.

THOUGH SIMPLE TO MAKE, THESE BROILED MUSHROOMS BURST WITH INTENSE FLAVOR, ESPECIALLY WHEN COOKED WITH A BIT OF CHEESE OR BACON.

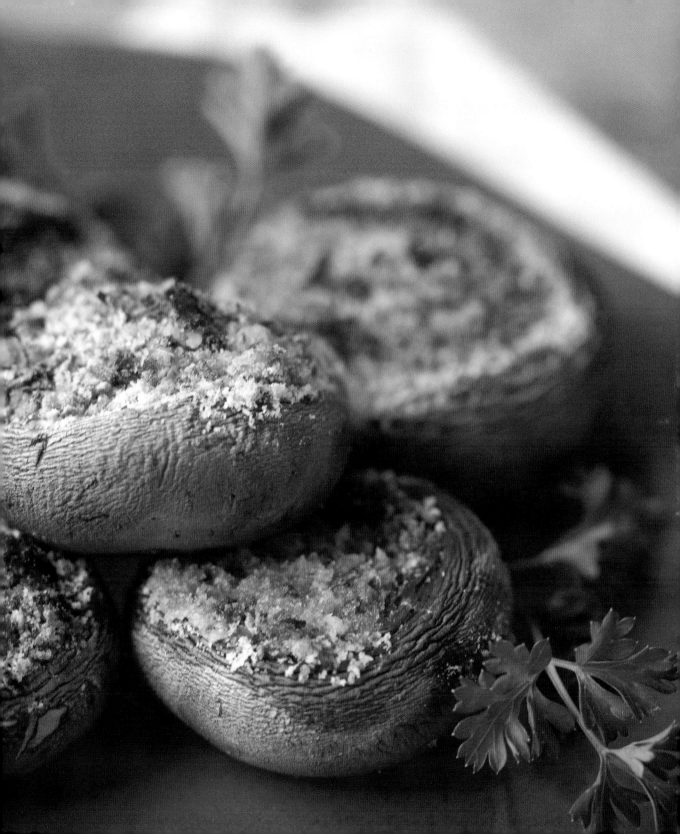

CELERY SAUCE
(Celery Sauce for Boiled Fowls)

Emma's original recipe calls six heads of celery, which is a lot of celery. Either this is a recipe for a large party or, possibly, Emma only used the inner, tender, hearts. Here we used two heads, discarding the outer leaves, which left just over one pound in weight. The stock could be taken from that used in boiling the chicken or whatever fowls were being cooked. Why not then boil the celery in the stock? Perhaps Emma felt the celery flavor would be too overpowering in the sauce without the preliminary boil in water. Possibly our modern celery is more feeble in flavor, grown, as it often is, in polytunnels with lots of water, rather than in the black soil of the Fens. Regardless, this sauce gives a unique flavor to an ordinary meal. Serves four.

2 cups (500 ml) chicken stock
2 heads of celery, the outer leaves removed,
 roughly cut
¾ ounce (20 g) butter
¾ ounce (20 g) flour
Salt, pepper, and a pinch of ground mace
3–4 tablespoons heavy cream
Squeeze of lemon juice

1. In a medium pot, bring the stock to a boil. Roughly cut the celery into 2-inch (5-cm) pieces, then cook in the boiling stock until tender but not soggy.

2. Drain the celery, reserving the stock. Arrange the celery pieces in a serving dish. Cover with foil and keep warm.

3. Melt the butter over a medium heat and stir in the flour. Cook for 3–4 minutes. Keep stirring so it does not burn.

4. Add 1 cup (250 ml) of the reserved stock, a little at a time, stirring so you get a smooth sauce. If it seems too thick, add a little more stock.

5. Season with pepper and mace. (Be cautious with the salt as the stock may have enough already.)

6. Pour in the cream and let the sauce bubble for 1–2 minutes. Add lemon juice and pour the sauce over the celery.

60760. Céleri plein doré à côte rose.
Celery, rose-ribbed Paris.
Sellerie, rostrippiger goldgelber Pariser.
Fr. 6 20 — 5 —

60764. Céleri plein blanc doré, C. Chemin.
Celery, Paris golden yellow large solid.
Sellerie, vollrippiger goldgelber Pariser.
Fr. 6 90 — 5 6

60784. Céleri violet de Tours.
Celery, red giant salad.
Sellerie, violetter Tours vollrippiger.
Fr. 6 30 — 5 —

ITALIAN VEGETABLE SOUP

This recipe is tinged with sadness. It was copied into Emma's book by Annie, the Darwins' first daughter, who died in 1851 when she was ten.

The soup is a little unusual in that it includes cucumbers along with the lettuces and peas but the result is a summer soup. It is very pretty, with the bright green of the peas and the darker strands of the shredded lettuce. The cucumber adds a pleasant crispness. Alas, all this will be lost if you follow Emma's original instructions and stew the vegetables for two hours. The tendency of the Victorians to cook vegetables for so long is partly explained by their belief, sternly stated by Eliza Acton, that "vegetables, when not sufficiently cooked, are known to be so exceedingly unwholesome and indigestible, that the custom of serving them crisp, which means, in reality, only half-boiled should be altogether disregarded when health is considered of more importance than fashion." So perhaps some brave "fashionable" people favored vegetables with a bit of bite. Even Miss Acton was not wholly consistent, recommending that Brussels sprouts be boiled for nine to ten minutes and small new potatoes ten to fifteen minutes, which many would find acceptable today. However, in her book, carrots, fully grown, need one and a half to two hours! The peas we used were frozen *petits pois*. If you have fresh peas, so much the better. Serves six as a starter and four as a main course.

2 tablespoons butter
1 small onion, chopped
2 crisp lettuces, shredded
1 large cucumber, peeled, quartered, de-seeded, and chopped
1¼ pound (550 g) shelled peas
3 cups (750 ml) chicken or vegetable stock

1 teaspoon sugar
2 egg yolks (optional)
2 tablespoons cream
Salt and pepper

1. Melt the butter in a medium pot. Cook the onion gently until soft and translucent.

2. Add the lettuces, cucumber, and half of the peas, and give the whole lot a good stir. Let the vegetables cook over a very low heat.

3. In a separate pan, bring the stock and the sugar to a boil. Add the remaining peas and boil for 1 minute or until the peas are cooked. Add salt and pepper to taste.

4. Whiz the stock and peas in a blender until you have a smooth, thin purée.

5. Add the pea purée to the first pot of vegetables. Raise the heat a little, bring to a boil, and simmer gently for 5 minutes. Taste again and add more salt and pepper, if needed.

6. Ladle into warm bowls, stirring a spoonful of cream into each.

NOTE: For a richer soup, mix 2 egg yolks with a few spoonfuls of cream and then add a ladle of the hot soup. Give this mixture a quick stir before pouring it into the pot of hot soup. Be careful not to let it boil or the yolks will curdle.

PEA SOUP
(*Pea Soop*)

This is a substantial soup. Follow it with cheese, fresh bread, and perhaps, fruit and you would have a good, informal lunch for four.

> 4 ounces (110 g) smoked, streaky bacon, finely chopped
> 1 onion, chopped
> 2 carrots, chopped
> 2 baby turnips, chopped
> 1 pound (450 g) peas, shelled
> Salt and pepper
> ½ teaspoon brown sugar
> 4 cups (1 L) chicken or vegetable stock,
> or use good quality stock cubes

1. Fry the bacon over a medium heat until the fat runs.

2. Add the onion, carrots, and turnips. Cook gently until they begin to soften.

3. Stir in the peas. If you are using frozen peas, cook until they are just thawed.

4. Season with salt (add carefully as the bacon will be quite salty) and pepper. Add the sugar.

5. Add the stock. Bring to a boil and simmer for about 10 minutes.

38

Pea Soop

Cut a quater of pound of bacon or leg of veal or beef into small bits one oion fry them with the meat untill litly brouned put turnip and Carrot fry ad one pound of peese boil till till till it is done a little brown suger thicken it with a little flown maid into a smooth past boil up and serve

NOTE: You can thicken the soup as Emma suggests, with a little flour, in which case it will be best stirred in and allowed to cook briefly, just before the stock is added. Alternatively, take 2–3 ladles of the finished soup, including the vegetables, and whiz them in a blender. Return this purée to the pan, where it will thicken the soup. A little chopped mint would also be welcome.

POTATO RISSOLES

The rissole of half a century ago was a dreadful thing: a meatball of indeterminate content hidden under a blanket of glutinous gravy. Not surprisingly, they have gone out of fashion or at least the name has. In fact, they continue to appear in the cuisine of many nations in countless forms. Little balls, usually, but not always, of meat spiked with garlic, herbs, and spices; rolled in breadcrumbs or wrapped in puff pastry; grilled, skewered, or simmered—there is hardly a nation without its own, individual variety. They are also a good way of using up leftovers—it just depends how you do it. What Emma was doing here was a little different. She was making a dough from cooked potatoes, rolling it out like pastry and wrapping it around thin slices of ham or beef, "in the manner of veal olives." This can be confusing, as in a veal olive the meat is on the outside, while here, the meat is inside with the potato covering it. Regardless, these are easy and fun to make. For the quantities given here, which will make about ten little rissoles, you don't need an egg in the mixture. With larger amounts, you can add a yolk or even a small whole egg, but it isn't really necessary, and you run the risk of having a sticky dough. Make sure to use floury potatoes, which are good for mashing, not the waxy kind. As for the fillings, experiment but make them well seasoned, in contrast to the potato. Finally, you can fry them in oil, but goose fat would be best.

> 8 ounces (225 g) potatoes, quartered if large
> 2 ounces (50 g) butter
> Salt and pepper
> 2 ounces (50 g) flour
> Thin slices of ham, or whatever you are using as a filling
> Oil or fat for frying

1. Place potatoes in a large pot, cover with water, and bring to a boil. Simmer until tender and remove from water. When cool enough to handle, peel them.

2. Using a potato ricer, mash them and add the butter while the potato is still warm. Mix it in with a fork. Season with salt and pepper.

3. Incorporate the flour into the potatoes, a little at a time, just until you have a firm, but soft dough. (The easiest way to do this is to use your hands.)

4. Put the dough on a floured surface and roll it out until it is about ¼ inch (0.5 cm) thick. Cut into rectangles about 2 x 3 inches (5 x 8 cm).

5. Season the ham and roll it up, like a cigarette.

6. Place the ham on the dough and roll up the dough, completely enclosing the ham. Pinch the ends, and the side seam together to seal.

7. Heat oil or fat in a frying pan. When a small cube of bread turns a good golden brown after being dropped in the hot fat, carefully fry the rissoles, turning them so that they cook evenly. Drain on absorbent paper and serve at once.

NOTE: You may use whatever you have at hand as a filling, seasoning it as you like. A little mustard might be a nice addition to the ham or other meat as well.

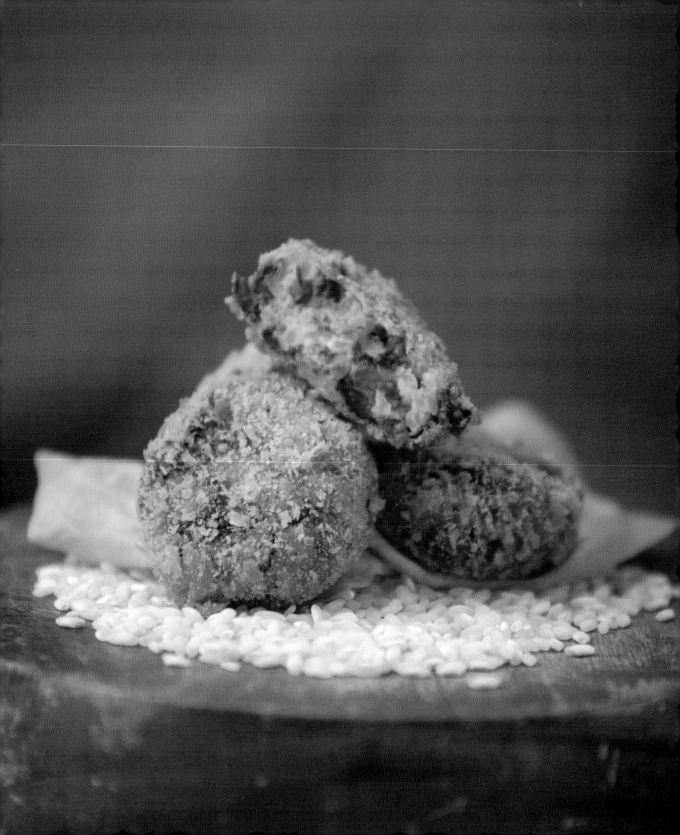

RICE PATTIES

In medieval times, rice was a rare and precious commodity, kept with the spices, under lock and key. By the nineteenth century, it was much more freely available, imported both from the Indian subcontinent and the United States. American rice was regarded by many as superior. Puddings were popular, but there were savory dishes, too. Perhaps the rice watched and timed so carefully by Darwin was eaten with the chicken curry from the recipe in Emma's notebook. Certainly Victorian cooks were quick to exploit its versatility. One recipe provides a wonderful example of their passion for culinary construction; rice is boiled, mashed, molded, and finally baked to form a fancy container, or casserole, complete with lid. In this, anything from a fricassee to stewed fruit could be brought to the table. Emma is not so ambitious, but when were her savory little cakes meant to be eaten? She gives no hint. Made very small, you could have them with a predinner drink; larger, perhaps as a supper dish, with a salad. You can experiment with the filling. From the instructions, it looks as if Emma put her filling into the middle of the patty, concentrating it at the center. You can do this, but we found the mixture very sticky, and it is easier to simply mix your chopped mushrooms, or whatever you are using, into the rice, and then form them into patties. We used Arborio rice, which is ideal for absorbing plenty of liquid. Makes about twelve patties.

MADE WITH ARBORIO RICE, THIS RECIPE YIELDS A DISH AS CREAMY AS RISOTTO BUT WRAPPED IN AN HORS D'OEUVRES-SIZED PATTY.

4 ounces (110 g) Arborio rice
2 cups (500 ml) milk
1 ounce (30 g) butter
1 ounce (30 g) Parmesan, grated
1 tablespoon chopped parsley
1 ounce (30 g) dried porcini mushrooms, soaked,
 drained, and finely chopped
Salt and pepper
1 egg, lightly beaten
2 ounces (50 g) breadcrumbs
Oil for frying

1. Blanch the rice in boiling water for 2–3 minutes. Drain.

2. Add the milk and butter to the rice and simmer very gently
 until all the milk is absorbed. Stir occasionally, being careful
 not to burn.

3. When all the milk is absorbed, and the mixture is very thick,
 mix in the cheese, parsley, and mushrooms. Season with salt and
 pepper and chill completely.

4. Take spoonfuls of the mixture and shape into small cakes. Dip in
 the beaten egg and roll them in the breadcrumbs.

5. Fry quickly in hot oil. Drain on absorbent paper and eat
 while they are hot and have a creamy texture.

SALAD DRESSINGS
(Salad and Mr. Sander's Salad)

Emma's book contains two salads. The first uses lettuces and beet root with a dressing that is obviously the precursor of bottled salad "creams," which were the mainstay of summer cooking in the days before mass travel and Elizabeth David broadened our horizons. Freshly made, it is surprisingly good—a light, more runny mayonnaise. A crisp lettuce would be ideal with boiled young beet root. How you combine the two vegetables is best left to individual inspiration as the color of the beet root, glorious in itself, has a truly dramatic, some would say lurid, effect on anything it touches.

> **For the dressing:**
> 2 hard-boiled eggs
> 1 teaspoon sugar
> ¼ teaspoon dry mustard (or ½ teaspoon Dijon mustard)
> Salt and pepper
> 1 tablespoon olive oil
> ½ cup (125 ml) light or heavy cream
> 3 tablespoons vinegar (tarragon, wine, and
> cider are fine, but avoid malt vinegar)

1. Sieve the hard-boiled yolks. This is important, otherwise you will have a lumpy dressing. (Chop the whites and add them to the final salad.)

2. Add the sugar, mustard, salt, pepper, and oil. Mix well.

3. Pour in the cream slowly, stirring constantly.

4. Add the vinegar slowly, tasting as you go.

The second salad is a simple modern dish—perhaps "timeless" is a better way of describing it. Today, we would call this a French dressing or vinaigrette.

For the dressing:
½ teaspoon salt
¼ teaspoon mustard powder
½ teaspoon sugar
Freshly ground black pepper
1 tablespoon vinegar (wine, tarragon, etc.)
3 tablespoons olive oil

1. Mix dry ingredients together.

2. Add vinegar.

3. Stir in the olive oil and mix well.

b

STEWED MUSHROOMS

The Darwins kept horses, and paddocks, being unmown, are often good places for field mushrooms. Other fungi certainly grew in the woods around Down House, which would have had much more flavor than the cultivated ones available today. Two hours of cooking, recommended in Emma's book, would surely have rendered them beyond all recognition, even if the heat had been very low. The Victorians did have many recipes for mushroom ketchup where, sprinkled with salt, they were left, sometimes for several days. They were gently stewed and the resulting liquid was drained off, seasoned, and bottled. This sauce was then used to add flavor and color to soups, stews, and the like. However, Emma's recipe seems to expect a result of recognizable mushrooms. You might stretch the cooking over a very low heat to twenty minutes at the most. Serves two to three.

> 1 ounce (30 g) butter
> 1 pound (450 g) mushrooms, cleaned and
> quartered, or sliced, depending on size
> 1 teaspoon flour
> 1 cup (250 ml) light cream
> Salt and pepper
> Buttered toast, for serving

1. Melt the butter in a large frying pan. Add the mushrooms and cook gently, stirring occasionally.

2. If a lot of liquid is released, raise the heat a little to reduce.

3. When most of the liquid has gone, sprinkle flour over the mushrooms and continue cooking for 1-2 minutes.

4. Pour in the cream. Bring to a gentle simmer and cook for 2-3 minutes. Season with salt and pepper.

5. Serve on slices of buttered toast or "snippets of toast"—fried bread.

Mushrooms Stewed

Peel them & put them in Salt & water wash them & put them in a stew pan with a little salt sprinkled over them, let them stew 2 hours, then add a little cream, season with pepper & Salt, thicken with flour & butter. Serve up with sippets of toast round the dish.

STEWED SPINACH
(*Stewed Spinage*)

Spinach has a remarkable way of disappearing. One minute you have a sink full of crisp green leaves, and the next, a distinctly unpromising lump in the bottom of a saucepan. Don't lose heart—there are several ways of preparing this vegetable, and Emma's method is simple and good. If your spinach is not young and tender, remove any long stalks. Delicious eaten on its own, or with eggs or fish, particularly smoked fish, this serves two as a side dish.

> ¾ pound (350 g) fresh spinach
> 2 tablespoons butter
> Approximately ½ cup (125 ml) heavy cream
> Salt and pepper
> Pinch grated nutmeg (optional)

1. Wash the spinach leaves well. Give the handfuls of leaves a good shake and pack them into a saucepan. No need for any extra water. Cover the pan and place over a medium heat.

2. After 1–2 minutes, remove the lid and stir the leaves with a wooden spoon, turning the top leaves to the bottom, so they all cook.

3. When the spinach is thoroughly wilted, let it bubble for another 1–2 minutes. Taste a small piece to make sure it is tender.

RICH IN FLAVOR AS IN HUE, STEWED SPINACH IS A WONDERFUL ACCOMPANIMENT TO ANY MEAL.

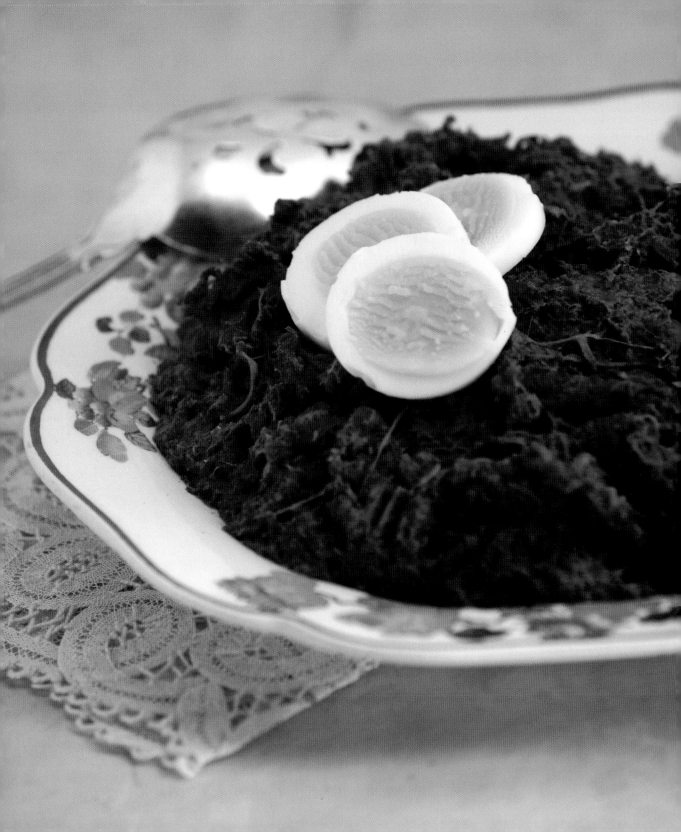

4. Pour the contents of the pan into a colander and plunge the sieve into a sink of cold water. This helps to keep the bright green color. Do not submerge completely, but make sure the spinach is in the water. Remove the colander from the water. Using a wooden spoon or, even better, your fist, press the spinach down, removing as much water as possible.

5. When you have extracted as much liquid as possible, put the spinach back in the saucepan over moderate heat. Add butter and with a wooden spoon mash or pound the spinach to break up the leaves.

6. Add just enough cream to give a thick purée. (You may not need to use the full amount.) Season with salt and pepper and a little grated nutmeg, if using. Serve at once.

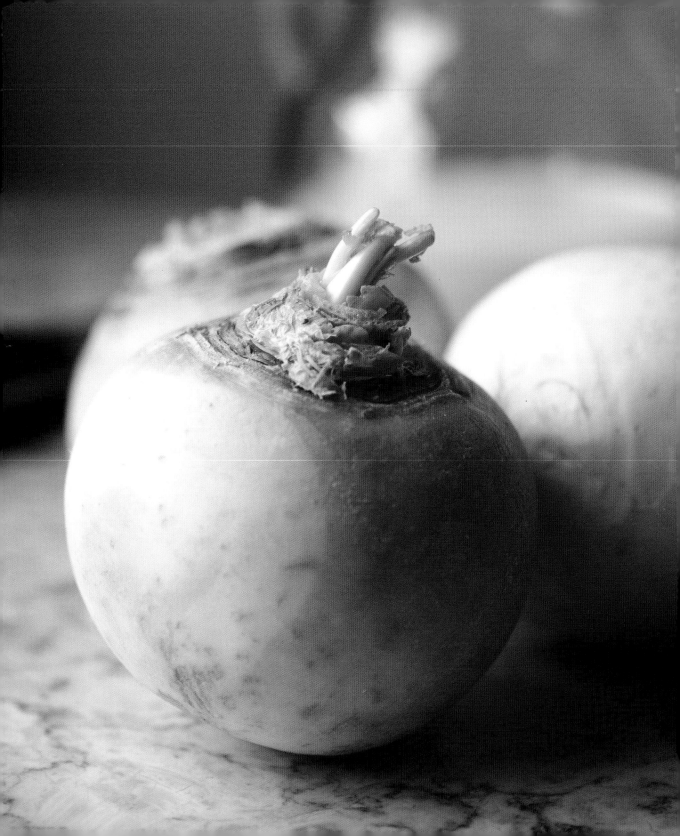

TURNIPS CRESSELLY

The house at Cresselly in South Wales was the family home of Emma's mother, Elizabeth (Bessy) Allen. After her own mother died, Bessy, then twenty-six, ran the house and raised her seven sisters. Her two brothers went away to school. Perhaps this way of cooking turnips was a family recipe that Emma inherited from her mother. Like most vegetables, turnips are best eaten young. Excess moisture, which can be plentiful in turnips, is drained off before the final addition of butter and cream. This method results in a delicately flavored mash, far removed from the watery mush often associated with this vegetable. Serves three to four as a side dish.

> 1½ pounds (700 g) young turnips, peeled and diced
> 2 ounces (50 g) butter
> 1 cup (125 ml) heavy cream
> Salt and cayenne pepper

1. Add the diced turnips to a pan of lightly salted boiling water and cook until tender.

2. Pour off most of the cooking water and transfer the turnips to a blender. Blend until you have a reasonably smooth purée.

3. Pour the purée into a colander, pressing it down, and leave to drain for at least 30 minutes—longer won't hurt. You will get rid of a surprising amount of liquid.

4. Just before serving, heat the butter and cream in a saucepan. When bubbling, add the turnips and mix well. Season with salt and a pinch of cayenne pepper and serve piping hot.

VEGETABLE SOUP

This is a good summer soup. Crisp lettuces work well here, keeping something of their structure. If the lettuces are shredded not too finely and the other vegetables cut fairly small, ten to fifteen minutes for the final simmering should be plenty. Serves four.

> 3 ounces (75 g) butter
> 3 onions, finely chopped
> 2 stalks celery, finely chopped
> 4 young carrots, chopped
> 3 heads of lettuce, shredded
> 2 handfuls baby spinach leaves
> 2 tablespoons chopped fresh herbs (parsley, thyme, marjoram, etc.)
> 2-3 teaspoons flour
> 4 cups (1 L) chicken or vegetable stock
> 2 handfuls of shelled peas
> Salt and pepper
> ½ cup (125 ml) heavy cream mixed with 2 egg yolks

1. Melt the butter, add the onions, cover, and, stirring from time to time, cook over a gentle heat until they are soft and golden. After about 5 minutes, add the celery and carrots and let them all stew together.

2. Add the lettuce, spinach, and herbs. Continue cooking for a few minutes.

3. Stir in the flour and let it cook for 1-2 minutes.

60702. Carotte jaune obtuse du Doubs.
Carrot, long yellow stump rooted.
Möhre, gelbe lange stumpfe Doubs.
Fr. 5 30 — 4/3

60708. Carotte blanche lisse demi-longue.
Carrot, white smooth intermediate.
Möhre, weisse Canadische halblange glatte.
Fr. 5 20 — 4/3

4. Pour in the stock and stir. Bring to a boil, add the peas, and simmer for 10 minutes. Add salt and pepper to taste.

5. Mix a ladleful or two of the soup into the cream and yolks and add to the soup. Do not let it boil again.

NOTE: You can also thicken the soup by whizzing a cupful in a blender and putting it back into the pan before adding the cream and yolks. This is even more effective if you add 2-3 diced new potatoes to the mixture. If you do this, add them along with the celery and carrots and omit the flour.

PUDDINGS AND SWEET THINGS

DARWIN LOVED SWEET things. Emma's recipe book includes more than sixty puddings, not counting the jams and preserves. Many of them have charming girls names: Olga, Natalia, Bertha, Pauline. Emma uses plenty of milk, lots of cream and eggs, and fruit. The orchard supplied apples, pears, and quinces; rhubarb came from the vegetable garden. Although Emma does not provide a recipe for rhubarb, it must have been featured in the menus. More than once Darwin notes in his diary that a bad night or an upset stomach was apparently caused by rhubarb. So did Emma.

She does not give recipes for many cakes, though three different kinds of gingerbread are given. (We provide two here.) This dessert was popular with the children, who would often venture into the cook's domain in search of a gingerbread treat. Variations on the custard theme were popular, and these were proper custards, not the sort made with powder. Emma gives only one recipe using chocolate: a chocolate milk jelly, which is not very exciting today but unusual, perhaps, for the Darwins.

ARROWROOT PUDDING

Arrowroot is a tasteless starch used as a thickener and well liked for the way in which it thickens while allowing sauces to remain translucent. Popular with the Victorians as an invalid food, they believed that, being fine-grained, it was easy to digest. Possibly this pudding was intended as nursery food. The consistency is pleasant enough. If the egg whites are whipped until stiff, it is a soufflé; if not quite so stiff, you have an aerated custard. Whatever the result, the polite might describe the flavor as delicate, the less charitable as bland. If you don't feel you are breaking faith with Emma and are not cooking for small children or invalids, you could add a strip or two of lemon peel or half a vanilla bean to the milk, letting them infuse for an hour or two before reheating the milk and assembling the dish. Serves three.

1 tablespoon arrowroot
1 cup (250 ml) milk, plus a little more for mixing the arrowroot
1½ teaspoons sugar
1 tablespoon butter
3 eggs, separated

IN PREPARATION: Preheat oven to 325°F (160°C). You will need a roasting pan slightly larger than your soufflé dish.

1. Mix the arrowroot to a smooth paste with a little cold milk.

2. Bring the milk to a boil and add it to the arrowroot, stirring all the time.

3. Add the sugar and butter.

4. Turn off the heat and add the egg yolks, whisking well.

5. Whisk the egg whites and fold into the custard.

6. Pour into a soufflé dish. Place the dish in the roasting pan containing 1 inch (2.5 cm) of water and bake for about 30 minutes or until risen and golden brown on top. Serve at once. Although rather deflated, leftovers can be eaten cold.

Arrowroot Pudding

Boil half a pint of milk. Take one table-spoonful of arrowroot wet with cold milk pour the boiling milk on it, stir it up with a bit of butter & sugar & the yolk of 3 eggs. Whip the whites to a froth, put them to it, put it in a mould & boil it three quarters of an hour.

BAKED APPLE PUDDING

The most famous batter pudding is Yorkshire pudding, traditionally served with roast beef. Jane Grigson tells of her grandfather's family, where the Yorkshire pudding, having done its duty by the beef, was then finished up with sweetened condensed milk! The Victorians had many recipes for sweet puddings with batter, so there is nothing particularly strange about this dish. Today, apples are usually baked without peeling them—the skins help them to keep their shape, so you finish up with apples still looking like apples, but beautifully soft and fluffy inside. With this dish, where the apples are peeled, they collapse on cooking and the juices and flavor spread into the surrounding batter—very nice, too. Use well-flavored dessert apples and serve with a sprinkling of sugar and plenty of cream. Serves four to six.

> 6 apples
> 2 tablespoons sugar, plus more for sprinkling
> ½ teaspoon finely grated lemon peel
> 1 tablespoon butter
>
> For the batter:
> 3 ounces (75 g) flour
> 1 cup (250 ml) milk
> 2 eggs

IN PREPARATION: Grease an ovenproof dish deep enough to hold the apples and batter. Preheat oven to 350°F (175°C).

1. Peel and core the apples. Place them in the prepared dish. In each
 hole, put a teaspoon of sugar, a little grated lemon peel, and top
 with a small piece of butter. Bake for 20 minutes. Remove the
 apples from the oven and raise the temperature to 400°F (200°C).

2. While the apples are baking, sift the flour into a bowl and make a
 well in the center. Add the milk, a little at a time, and mix to a
 smooth batter. Beat in the eggs, one at a time.

3. Pour the batter over the apples and bake for about 30 minutes, or
 until well risen and brown on top. Sprinkle with sugar and serve at
 once with cream.

BURNT CREAM

Burnt cream, or crème brûlée as it is now more commonly known, is a famous English pudding and certainly one of the best. The contrast between the cool, rich custard and the crisp, glassy layer of caramelized sugar is truly delicious. In fact, it is a simple dish of cream, egg yolks, and sugar but made in surprisingly different ways. What is generally agreed upon is that you boil the cream and then pour it onto well-beaten egg yolks, stirring as the mixture cools. After that, opinions differ; some continue to cook the custard until it "coats the back of the spoon." Others bake it in a low oven. Still others simply let the mixture cool completely, then chill it before adding the final layer of sugar on the top.

In Elizabeth Raffald's *The Experienced English Housekeeper* (1769), you find the recipe closest to the one given by Emma. This, interestingly, includes whole eggs and flour. No mention is made of any flavoring—orange-flower water would have been popular in the eighteenth century, vanilla would be the obvious choice today. Then, looking more closely at Emma's original ingredients and quantities, more questions arise. One tablespoonful of flour to only one cup of cream will surely result in an unacceptably thick mixture. And to what extent should the egg whites be whipped? As though you're making meringue? A trial run with less flour, about half, and whites whipped to the "soft peak" stage, and then carefully folded into the cream/egg-yolk mixture, produced custard that tasted fine but remained rather runny and by the following day had become considerably more so. Any topping was doomed to sink. A second attempt, using the full tablespoonful of flour, was much more successful. You do have to boil the cream and flour gently for about ten minutes to make sure the flour is properly cooked, otherwise it will taste raw. Serves four.

WITH ITS RICH CUSTARD BASE AND CRUNCHY TOPPING, THIS DESSERT IS NOTHING SHORT OF PERFECTION.

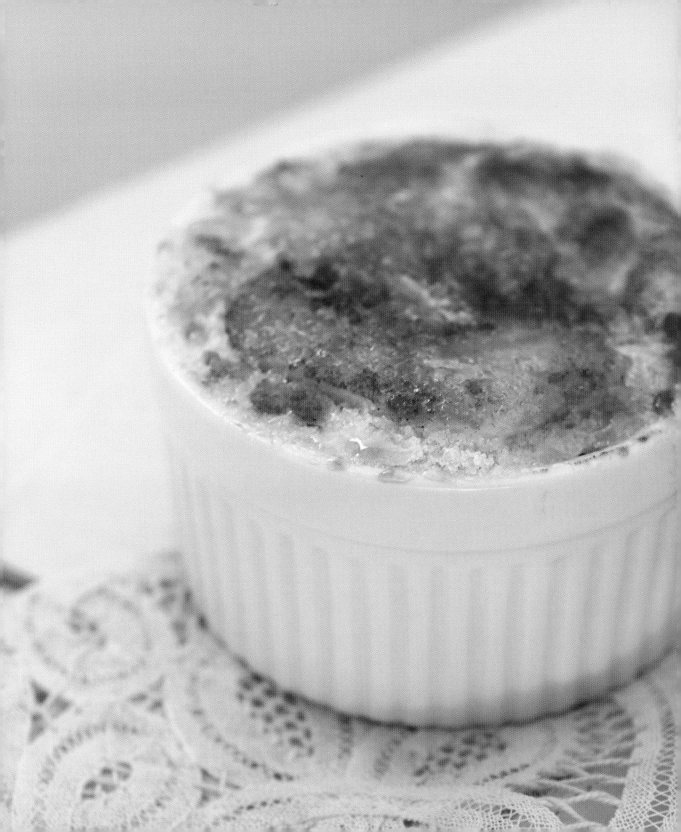

1 tablespoon flour
1 cup (250 ml) heavy cream
2 eggs, separated
2 ounces (50 g) superfine (caster) sugar, plus 1 teaspoon

1. Mix the flour in a medium saucepan with a little milk or water before adding it to the cream; this will prevent lumps. Bring to a boil and cook gently for about 10 minutes to ensure the flour is thoroughly cooked.

2. Add the egg yolks and 1 teaspoon of sugar. (You can do without the sugar at this stage if you like, as the caramelized top will provide plenty in the finished dish.)

3. Beat the egg whites only until they form a frothy liquid and add them to the pan.

4. Taste and, if you are satisfied that no hint of a floury taste remains, pour the mixture into an ovenproof dish and allow to cool.
Chill overnight.

THE RESULT? A well-set custard with no hint of flour and possibly a lighter texture than one made only with cream and yolks. All that remains is to "salamander" it. The salamander, an iron disc with a long handle, must have been a fearsome instrument when in use. The disc is heated red-hot, then passed to-and-fro over and close to the dish. Fortunately, today, there are other solutions, the most recent being the culinary blowtorch. Simply sprinkle an even layer of superfine (caster) sugar over the custard and direct the flame over the surface until the desired effect is obtained. Lacking one of these gadgets, the usual instruction is to place the dish, complete with its sugar, under a grill preheated to its maximum temperature. An even, glassy smoothness will result. It is not as easy at it sounds. It takes a long time for the sugar to melt—while you worry that the dish, if it is not metal, will crack or the custard begin to bubble. Then there is the problem of evenness as the sugar develops "hot spots," where it starts to burn locally and you have to turn the dish about. All this quite possibly while you are on your knees, if your grill is not at eye level! Far simpler is to put the superfine (caster) sugar in a small heavy saucepan and heat it gently until it melts. Do not stir. When it starts to color and bubble, tip the pan in a circular motion so the sugar is well mixed and dissolves completely. Watch it carefully—it can burn very quickly. What you want is a deep auburn color with that wonderful caramel smell. Then, holding the custard dish in one hand, pour the molten sugar onto the top, tipping the dish so it covers evenly. The sugar will bubble up, but do not worry, it will soon subside. With this method, a beautiful thin layer is achieved. Do this a couple of hours before you want to eat. As soon as the sugar has cooled, chill until needed.

BURNT RICE

Burnt Rice is rice pudding with pretensions. The beaten egg whites lighten the rice mixture, and the crisp sugar topping turns this pudding into a poor man's crème brûlée. Like several of Emma's recipes, if you approach them without fixed ideas of what the results ought to be, the outcome is often surprisingly good. Rice pudding has its fans; others dislike it intensely. Burnt Rice might just make a few converts. Serves four.

> 2 ounces (50 g) pudding (or medium grain) rice
> 2 cups (500 ml) milk or 1 cup (250 ml) milk
> with 1 cup (250 ml) light cream
> 1 ounce (30 g) butter
> 2 ounces (50 g) sugar
> 2 eggs, separated

IN PREPARATION: Preheat oven to 350°F (175°C).

1. Simmer the rice in the milk until it is thoroughly soft and has the consistency of thick custard. This takes about 20-30 minutes. Stir frequently to prevent burning.

2. Remove from the heat and mix in the butter, 1 teaspoon of the sugar (the topping will provide plenty of sweetness), and the egg yolks. Stir well. Leave to cool a little.

3. Whip the egg whites until they stand in soft peaks. Gently fold them into the rice mixture.

4. Pour the mixture into a shallow ovenproof dish and bake it for 20-25 minutes. (While not mentioned by Emma, this extra cooking will stabilize the egg whites, which otherwise will begin to become watery.)

5. Sprinkle the remaining sugar evenly over the top and place under a hot broiler for a few minutes or follow the instructions given under Burnt Cream (page 123). Eat with cream while still warm.

CHOCOLATE CREAM

This is the only recipe in Emma's book that mentions chocolate. The chocolate Emma calls for is described as "Spanish" or "rough." In the late seventeenth century, supplies of chocolate came to England from Jamaica, only recently captured from Spain. Possibly the chocolate continued to be though of as "Spanish." At that time, chocolate was popular as a drink, but it was well into the nineteenth century before "eating" chocolate became available. Manufacturing developments, cheaper sugar, and a reduction of import duties on cocoa beans in 1853, all contributed, but chocolate was still a luxury. Milk chocolate didn't appear until the 1870s. The amount of sugar in Emma's recipe suggests the chocolate she used was semi- or bitter-sweet. We used a dark, 85 percent cocoa chocolate and were able to reduce the sugar greatly. If you follow Emma's original instructions and dissolve the chocolate in the milk, heating it gently, you finish up with a layer of chocolate particles on top of the mold (which becomes the bottom when you turn it out). Some of our tasters liked this; if you prefer your cream smooth, it would be better to dissolve the chocolate first, in a bowl over hot (not boiling) water and then mix in the warmed milk gradually. Reading through this recipe you would be forgiven for thinking that this is a chocolate blancmange; it is. The flavor is good and the appearance might be more attractive if it was put to set in pretty individual pots or glasses, with a little poured cream on top rather than turning it out. Serves four.

4 sheets of leaf gelatin or 2 teaspoons powdered
4 ounces (110 g) chocolate
2 tablespoons sugar
2 cups (500 ml) milk

1. Cut up the sheets of gelatin and soak them for 5 minutes in cold water.

2. Break the chocolate into small pieces and melt in a small bowl over hot water.

3. Combine the milk and the sugar in a pot and heat gently, stirring until the sugar is dissolved.

4. Add the warm milk to the chocolate gradually, stirring constantly.

5. Squeeze the surplus water from the gelatin and add it to the chocolate mixture. Stir until dissolved.

6. Pour into a jelly mold or individual glasses and, when cooled, refrigerate until set. If you want to turn it out, place the mold briefly in a sink of hot water and turn out onto a serving plate.

Soak the gelatine an hour or more in water. Grate the chocolate & put it with the milk & gelatine into a jug, Stand it in a saucepan of water on the fire. Stir occasionally when the water boil, stir for a quarter of an hour. Then pour into shapes. till cold.

CITRON PUDDING

As with Burnt Cream, this is a custard recipe that includes enough flour to set the food police tut-tutting. Just why it has become so wicked to thicken sauces, sweet or savory, with a little flour is a bit of a mystery. Of course, you do have to make sure that it is thoroughly cooked, as any hint of the taste of raw flour will detract from the finished dish. The citron used by Emma was almost certainly in the form of candied peel. The fruit, *Citrus medica*, is a very large, thick-skinned relation of the lemon. The most likely place to find some—apart from a shop specializing in such exotica—is in a pack of good quality candied peel, the sort often sold for cakes, puddings, and mincemeat in the run-up to Christmas. Check the list of fruit on the packet. The thickness of the peel and its greenish yellow color make it easy to recognize among the orange and lemon rinds. Be sure, too, to buy the kind that comes in large pieces for you to cut up. This is not an exercise to be recommended with the ready-chopped sort. Failing all this, the finely grated rind of a lemon will do as well. In fact, you may prefer the custards without the obvious "bits" that are noticeable, however finely you chop the peel. Serves six.

Citron-pudding

The yolks of 4 eggs, 1 spoonful of flour of a pint of cream 2 ounces of sifted Sugar, and some citron –
Baked in small cups.

1 tablespoon milk
1½ teaspoons flour
1 cup (250 ml) cream, light or heavy
4 egg yolks
1 ounce (30 g) sugar
Rind of 1 lemon, grated, or a slice of candied
 citron peel, chopped very small

IN PREPARATION: Preheat oven to 300°F (150°C).

1. In a heavy saucepan, mix the flour with a little milk to a smooth consistency. Stir in the cream.

2. Bring to a gentle simmer, stirring all the time, and cook for 3-4 minutes. Taste to make sure there is no hint of raw flour.

3. In a bowl, beat the egg yolks with the sugar. Add the chopped citron or the grated lemon rind.

4. Pour the hot cream onto the egg yolk mixture, stirring as you pour.

5. Divide the custard between 6 small ramekins and place in a roasting pan containing about 1 inch (2.5 cm) of water. Bake for 25 minutes.

6. Remove the ramekins from the water, cool and chill before eating, either on its own or with fruit.

COMPOTE OF APPLES

Dr. Joseph Hooker contributed this recipe. Even though he was a great botanist, perhaps he was not familiar with the variation in behavior of different varieties of apples when cooked. Any apples might do, but it is better to avoid the kind that will collapse on cooking. They make good applesauce, but here it will be nicer if the pieces of fruit retain their structure and shape. A well-flavored baking apple (dessert apple) would be best. Serves four.

> ½ pound (225 g) sugar
> 1 cup (250 ml) of water
> 6 medium-sized baking apples

1. Put the sugar and cold water into a pot and heat slowly, stirring until the sugar is dissolved.

2. Bring to a boil and simmer for 4-5 minutes.

3. Peel, core, and quarter the apples. Poach them in the boiling syrup until just tender. Test them with the point of a knife; the knife should go in easily but the apples should still be firm.

4. Remove the pan from the heat and let the apples cool in the syrup.

5. If you like a heavier syrup, strain the apples, place them in a serving dish, and boil the syrup to reduce it further. Finally, pour it back over the apples.

TASTY ON ITS OWN, COMPOTE OF APPLES CAN ALSO BE SERVED AS AN ACCOMPANIMENT TO BREAKFAST ITEMS, SUCH AS TOAST, FRENCH TOAST, WAFFLES, PANCAKES, OR AS A TOPPING FOR ICE CREAM OR POUND CAKES.

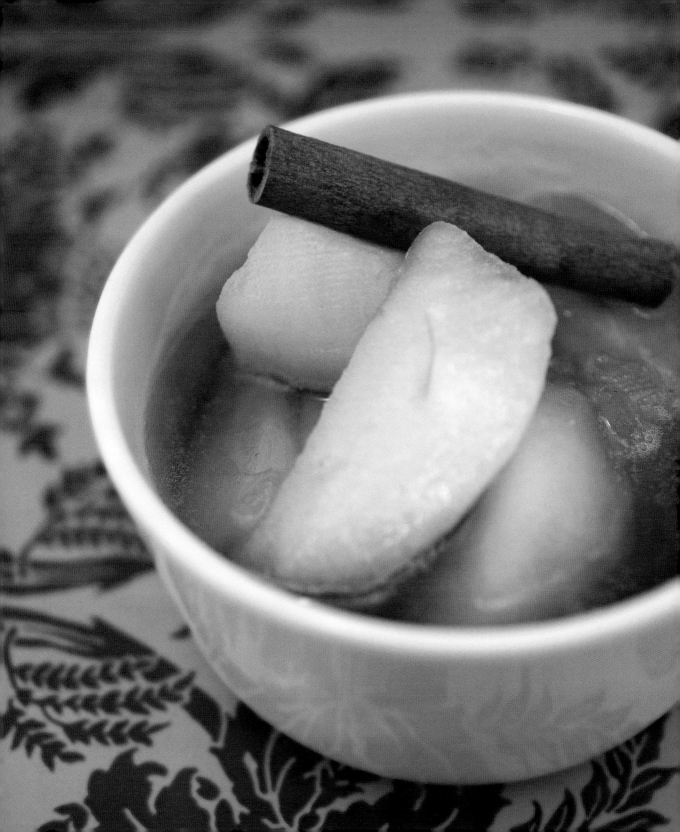

GINGER BISCUITS
(*Ginger Bread*)

This is cooking on an almost commercial scale! We divided Emma's ingredients and original quanities in four and still ended up with more than fifty little gingerbread men. Like a modern gingerbread cookie, they were hard—perhaps not suitable for the dentally challenged—but the flavor was good and you can certainly taste the honey. Using a variety of cookie cutters, they would make lovely, old-fashioned, Christmas tree decorations. Just before baking, make a hole in each with a plastic drinking straw, through which you can thread a narrow ribbon to hang them on the tree.

> 4 fluid ounces (120 ml) honey
> 4 ounces (110 g) brown sugar
> 2 ounces (50 g) butter
> ½ ounce (15 g) powdered ginger
> 8 ounces (225 g) flour

IN PREPARATION: Preheat oven to 325°F (160°C).

1. Put the first three ingredients in a small saucepan and place over gentle heat—just enough to melt the butter and blend everything together.

2. Sift the flour and powdered ginger into a bowl, make a well in the center, and pour in the contents of the saucepan.

3. Mix together and knead the dough with your hands for 3-4 minutes. Cover the bowl with a cloth and leave to rest in a warm place for 1-2 hours.

4. Roll out on a floured surface to about ¼ inch (0.5 cm) thickness. Cut into shapes and place on a lightly greased and floured baking sheet. This dough doesn't spread or rise much, so you can place them close together, but not touching.

5. Bake for about 12 minutes. Watch them carefully, and don't let them darken round the edges; the flavor is best when they are still a rich "ginger" color.

6. Carefully lift them onto a wire rack. They will crisp up as they cool. Store in an airtight container.

NOTE: You can, of course, decorate these biscuits with icing after they have cooled. If you want to put currants on, for eyes, etc., they should go on before baking.

GINGERBREAD

This is a gingerbread cake, moist and dark. We used roughly half of Emma's suggested ingredients, and used more molasses and less sugar. We thought the flavor would be better. You could use self-rising flour; simply omit the baking soda.

35　　　　Gingerbread

2 ½ lb flour

½ lb butter

½ lb treacle

1 3/4 lb sugar

1 oz ginger

2 pennyworth essence of lemon

2 eggs

Melt the butter & treacle together & mix with the other things.

1 pound (450 g) flour
½ ounce (15 g) ground ginger
1 teaspoon baking soda
4 ounces (110 g) butter
4 ounces (110 g) brown sugar
12 fluid ounces (355 ml) dark molasses
1 teaspoon lemon extract
2 eggs, lightly beaten

IN PREPARATION: Preheat oven to 350°F (175°C).

1. Line a 9-inch (20-cm) square baking pan with parchment paper.

2. Sift the flour into a large bowl. Add the ground ginger and the baking soda.

3. In a small saucepan, over low heat, melt the butter, brown sugar, and molasses together. Add lemon extract.

4. Make a well in the flour and add the mixture from the saucepan. Mix together thoroughly.

5. Add the beaten eggs and mix well.

6. Pour into the prepared pan and bake for about 50 minutes. Test with a toothpick. If it comes out clean, the cake is done. If not, bake for a few minutes more.

GOOSEBERRY CREAM

The gooseberry was a popular fruit in nineteenth-century Britain, particularly in the north and midlands of England, while, according to Mrs. Beeton, "in Scotland there is scarcely a cottage-garden without its gooseberry-bush." This was in marked contrast to France, where the gooseberry was relegated by name (*groseille maquereau*) to the one lowly function of featuring in a sauce for mackerel. British enthusiasm led to the introduction of many new varieties, both for dessert and cooking. Keen amateur growers formed gooseberry clubs and organized competitions, most of which concentrated on size. The Egton Bridge Old Gooseberry Society, founded in 1800, still holds its annual fair, where the champion fruit now weighs in at around two ounces. (These monster berries are obtained by stripping all the fruit but one from the bush.) Today, gooseberry bushes still grow at Down House, some with the look of considerable antiquity, with thick stems and few leaves but, in June, laden with fruit. The Darwins' third son, Francis, remembers eating gooseberries in the garden with Dr. Joseph Hooker, their great family friend: "The love of gooseberries was a bond between us which had no existence in the case of our uncles, who either ate no gooseberries or preferred to do so in solitude." At first glance, Emma's recipe suggests a fruit fool, which many cooks nowadays prefer to make with a relatively rough texture, the fruit crushed and mashed rather than sieved to a silky smoothness. Emma's Gooseberry Cream is more like a fruit blancmange as she adds isinglass, a form of gelatin made from the swim bladders of certain fish. Her last instruction, to put it in a mold, raises the question of whether

it should be turned out for serving. However, the result is a more delicate pudding if the gelatin is kept to the minimum required to make it easy to serve and not so sloppy to eat. Put it in a pretty serving dish instead or, better still, into individual glasses. Emma makes no mention of elderflowers, the flavor and perfume of which go remarkably well with gooseberries—a culinary marriage made in heaven. Frustratingly, the flowers are often over before the fruit comes into season. However, a spoonful or two of elderflower liqueur (cordial) will do instead. This recipe will work equally well using rhubarb, black currants, apricots, etc. Serves at least six.

A WELCOME DEPARTURE FROM THE ORDINARY.

2 pounds (900 g) gooseberries
4 sheets of leaf gelatin or ½ ounce (15 g) powdered gelatin
6 ounces (175 g) sugar
2 tablespoons elderflower liqueur (cordial), optional
1 cup (250 ml) heavy cream

1. Wash the gooseberries and pinch off any remnants of the stem or blossom from either end. Cook the berries with a spoonful of water in a saucepan over low heat until the fruit begins to break up and is soft. Whiz in a blender or food processor, then pass through a sieve to get rid of the seeds.

2. Soak the gelatin in cold water for 4-5 minutes. Pour off the excess water. Heat the gelatin in a small pan over very low heat and stir occasionally until it melts. Do not let it boil.

3. Return the gooseberry purée to the rinsed saucepan, add the sugar, and stir over low heat until it is dissolved. Taste and add more sugar if necessary. Stir in the melted gelatin. Add the elderflower liqueur, if you are using it, and let cool.

4. Whip the cream and fold into the gooseberry purée. Pour into a serving dish or individual glasses and chill. The flavor will be better if is eaten not too cold. Fine shortbread or other similar cookies are a good accompaniment.

ITALIAN CREAM

Italian Cream is a pudding related to the posset and syllabub family of milk and alcohol concoctions. It is very simple to make but beware as you whisk the cream. After adding the lemon juice and brandy, the cream will thicken very quickly. Before you know it, you will have something resembling cream cheese. In good kitchenware shops, you can get little heart-shaped porcelain molds, usually French, with drainage holes in them. They must be intended for creams like this one, but it seems an extravagant investment for what would surely be infrequent use. Serves four.

> 1 cup (250 ml) heavy cream
> Juice and finely grated peel of ½ a lemon
> 1 tablespoon sugar
> 1 tablespoon brandy

1. Whisk the cream until it begins to thicken.

2. Add the rest of the ingredients and continue whisking until the cream is thick and fluffy but you can still pour it into a sieve or colander lined with a piece of damp cheesecloth or paper towel.

3. Refrigerate and leave to drain for 24 hours. This dessert is very good served with fresh or stewed fruit.

LADY SKYMASTON'S PUDDING

Jane Grigson wrote, "A generous hand with the cream—not to mention butter and eggs—has been the making of many of the best English puddings." This is certainly true of several of Emma's recipes. Light, heavy, whipping, extra-thick, clotted, soured—today, the choice is bewildering. In this case, Lady Skymaston is better served by milk. It is difficult to know exactly what Emma's cream was like, but this pudding, despite its noble name, is a simple caramel cream or custard—what the French call a *crème renversée*. Make it with too rich a cream and you will have a problem turning it out, and the Victorians were passionate about turning things out. Their festive supper tables must have groaned under the weight of these glossy castellated creations, everything from quail's eggs in aspic to blancmanges and jewel-like fruit jellies. So for this pudding, use milk or, just possibly, half milk and half light cream. Serves six.

> 2 ounces (50 g) sugar, plus 2 tablespoons
> 2 cups (500 ml) milk (or half milk and half light cream)
> 5 eggs
> A few drops of vanilla extract (not in Emma's original ingredient list, but it does improve the flavor)

IN PREPARATION: Preheat oven to 300°F (150°C).

1. Heat 2 ounces (50 g) sugar gently in a heavy pan (copper is ideal) until it melts. Do not stir. Instead, tilt the pan in a circular movement to mix. Take care that it does not burn. When it is bubbling and a deep golden color, pour it into an ovenproof dish—a soufflé dish is ideal—again tipping the dish so that the sugar covers the base. You need not be too exact about this, as the caramel will dissolve as the custard chills.

2. Heat the milk with the remaining sugar. Remove from the heat just before it boils.

3. In a bowl, beat the eggs and add the vanilla. Pour the hot milk onto the eggs, stirring as you do so. Strain the mixture into the caramel-lined dish.

4. Place the dish in a roasting pan containing about 1 inch (2.5 cm) of hot water and bake for about 1 hour until set. Once a toothpick inserted comes out clean, the custard is done. Cool and chill overnight; turn out onto a serving dish deep enough to hold the liquid caramel sauce, which will surround the pudding.

NESSELRODE PUDDING

If charts for puddings existed as they do for popular songs, then Black Forest Gateau, Baked Alaska, and Tiramisu would have topped them at different times. Nesselrode Pudding must have been similarly fashionable for several decades in the nineteenth century. Nesselrode himself was a Russian statesman active during the Napoleonic wars, present at the Congress of Vienna (1814-1815), and a signatory, in 1856, of the Paris peace agreement after the Crimean War. He was a great survivor. In the course of his long career, he had many dealings with that other wily statesman, Talleyrand. For a time, the great French chef Antonin Carème worked for Talleyrand and indeed went with him to Vienna in 1814. Perhaps it was there that he created the pudding and paid Nesselrode the compliment of naming it after him. Both Eliza Acton and Mrs. Beeton give a recipe for Nesselrode Pudding in their books and both attribute it to Carème, though neither admits to having made it. Obviously his name gave the recipe a certain cachet. Carème, also chef for a time to the Prince Regent, was famous for his elaborate and ambitious creations, and, indeed, the pudding described by the English ladies is very demanding. Sweetened and puréed chestnuts, a rich custard, fruit soaked in maraschino, an Italian meringue mixture, all frozen and molded into exotic shapes at different times, meant this pudding was not for the inexperienced or single-handed cook. Fortunately, for present purposes, Emma's version is a much simplified one. A small quantity of ground almonds is substituted for "forty best Spanish chestnuts" and twelve egg yolks become six. What we have here is a rich ice cream with dried fruit and a glass of brandy to make it special. Serves six to eight.

COLORFUL SLICES OF DRIED FRUIT MAKE THIS DESSERT A STAND OUT.

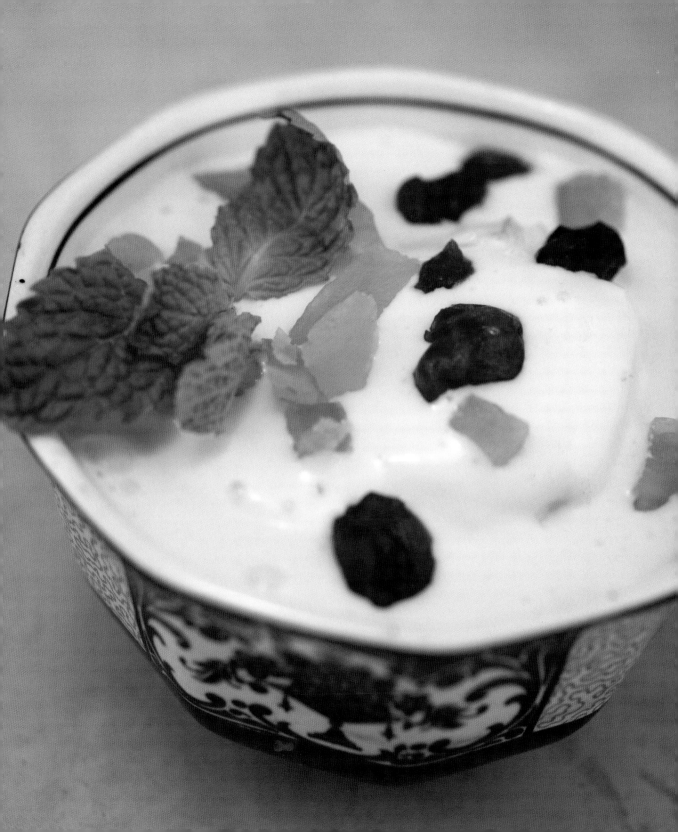

Nesselrode Pudding

Prepare a custard of one pint of cream, half a pint of milk, yolks of 6 eggs, half a stick of vanilla, one oz of sweet Almonds pounded, & ¼ lb of sugar: put in a stew pan over a slow fire, & stir to a proper consistency being careful not to let boil; when cold add a wine glass of brandy; partially freeze & add 2 oz ½ lb of preserved fruit cut small; mix well & mould. (Basket shape generally used.) ~~mould~~

8 ounces (225 g) dried fruit, finely chopped
¾ cup (175 ml) brandy, Maraschino, or any fruit liqueur
½ vanilla bean
2 cups (500 ml) heavy cream
1 cup (250 ml) milk
6 egg yolks
2 ounces (50 g) sugar
1 ounce (30 g) ground almonds

1. If the dried fruit includes glacé cherries, large raisins, or other large fruits, chop them into smaller pieces. Pour the brandy over them and leave to soak overnight.

2. Split open the vanilla bean lengthwise and scrape out the tiny seeds into the cream along with the outer bean. Bring cream and milk to a boil in a saucepan.

3. In a medium bowl, beat egg yolks with the sugar. When nice and creamy, beat in the ground almonds.

4. Discard the vanilla bean pieces and pour the hot cream and milk onto the egg yolk mixture, beating constantly.

5. Transfer the custard to a double boiler and, stirring constantly, cook over a medium heat until the custard thickens. Have patience as it may take 10 minutes or more and it is important not to let it boil.

6. Remove from the heat, add the brandy and fruit, and stir well. Let the custard cool. Refrigerate.

7. When thoroughly chilled, pour the mixture into an ice cream machine and freeze according to the manufacturer's instructions. If you do not have a machine, put the mixture into a suitable container and freeze for a couple of hours. When the ice cream begins to harden around the edges, give it a good stir and freeze again. For a really creamy consistency, you may need to repeat this step.

8. Soften the ice cream slightly in a refrigerator for some time before serving.

ORANGE POSSET

Historically, a posset was a drink, usually milk, curdled with beer or wine. Considered a delicacy, it also had medicinal overtones. Recently, possets have seen something of a revival, taking over from syllabubs, that other rather similar pudding, which had previously seen a comeback in the late twentieth century. Emma's posset is luxurious—cream, syrup, and wine. She flavors it with orange. We have included some ordinary orange juice in the syrup. Better still would be a spoonful or two of Seville orange juice. These bitter fruits are used to make orange marmalade and are usually in season early in the New Year. Their juice would add a more sophisticated flavor to the posset, balancing its sweet richness. Without Sevilles, a teaspoon of orange extract will enhance the taste. Emma's quantities have been halved. Emma's "tundish" is a funnel. Serve in small glasses with biscuits—*langues de chats* would go well here. Serves six to eight.

> 1 orange
> 2 ounces (50 g) sugar
> ½ cup (125 ml) sweet wine (such as a
> Spanish, orange-flavored Muscatel)
> 1 teaspoon orange extract
> 2 cups (500 ml) cream

1. Using a zester or a sharp knife, peel the rind from the orange without taking any of the pith. Cut into small strips. Squeeze the orange and reserve the juice.

Fig. 3. *Fig. 4*

2. Place 5 fluid ounces (150 ml) of water in a small pan. Add the zest and the sugar. Bring to a boil and simmer gently for 10 minutes. Strain and keep the strips of zest to decorate the finished posset.

3. In a large bowl, combine the wine, orange juice, and orange extract with the syrup.

4. In a separate bowl, whip the cream lightly, so that it is fluffy but still fluid enough to be poured.

5. Pour the cream onto the syrup. By all means do it, as Emma suggests, from a height (within reason). Fold cream and syrup together with a few strokes, using a large spoon, and pour into individual wine glasses. Decorate with the reserved strips of orange zest.

PEARS TO STEW

For most of recorded time, pears have been considered superior to apples. Perhaps their fragrant and soft buttery consistency, when perfectly ripe, has had something to do with this. The difference between the two fruits has been aptly described: while an apple should "be crisp and crunchable, a pear should have such a texture as leads to silent consumption." The problem is that the moment of perfect ripeness in a pear is very short—often as little as a day. Certainly for this recipe you need fruit not quite at its peak. We used Doyenné du Comice, considered by many to be one of the best, and they were definitely some way from perfect ripeness—almost "crunchable." Even after thorough cooking, the pears were still quite firm and wonderfully fragrant from the cloves and lemon. We tried transferring the fruit to a clean dish and putting it back in the oven for another hour to dry out. We don't recommend this because the pears end up unappetizingly brown. With a little more syrup, the fruit could be poached for, say, half an hour, barely simmering, and then left to cool in the juice. The pears retain their coloring better with this method. Serves four.

> 2 large pears
> 1 tablespoon sugar
> 6 cloves
> 1 strip of lemon peel

IN PREPARATION: Preheat oven to 200°F (90°C).

1. Cut the pears into quarters. Peel and core them. If they are very large, cut the pieces in half again.

2. Place them in an ovenproof casserole. Add 2-3 tablespoons of water and a sprinkling of sugar.

3. Add the cloves and lemon peel, cover, and cook in a very low oven for 4 hours. (The slow oven of an Aga is ideal.)

SCOTCH CAKE

The *Oxford English Dictionary* defines a gill as "a measure containing one fourth (or locally, one half) of a standard pint," which one was recognized in 1850s Kent would take too long to discover, but from what we know of Emma, she probably used the smaller one. She gives no instructions for making this cake, so two methods were tried. The first was the classic method, in which butter and sugar were creamed together, the eggs and brandy then beaten in, a little at a time, and the fruit and flour folded in at the end. The second was the boiled fruit method: butter, sugar, fruit, and any liquid. In this case, the brandy and a little orange juice were all placed in a saucepan, brought to a boil, and simmered very gently for five minutes. The mixture was then left to cool completely, then the eggs were beaten in, and the flour added. In the second trial, we used brown sugar instead of superfine (caster) sugar. The results were very similar. On first tasting, the cake seemed a little dry and the texture was rather close. Some tasters were reminded of pieces of fruit cake, wrapped in cellophane, that came with cups of tea at British railway stations. However, stored in an airtight container, it keeps well and, indeed, seems to improve. This is a sturdy cake, one you could take on long hikes without worrying that it would get squashed in your backpack or disintegrate into crumbs. A "good plain cake" is phrase that comes to mind, although such a cake does not usually have fruit in it. The second method involves much less hard work, bypassing as it does the creaming of butter and sugar. To use it, simply follow the instructions above. In both cases, we halved the original quantities given by Emma, as her cake is large.

8 ounces (225 g) butter

8 ounces (225 g) sugar (brown or superfine)

2 large eggs

2½ fluid ounces (75 ml) brandy

2 tablespoons orange juice

8 ounces (225 g) candied peel or a mixture of dried fruit

10 ounces (280 g) self-rising flour

IN PREPARATION: Preheat oven to 325°F (160°C). Line an 8 x 8 x 2-inch (20 x 20 x 5-cm) square cake pan with baking parchment.

1. Beat butter and sugar together until light and fluffy.

2. In a separate bowl, beat the eggs well. Add the brandy and orange juice.

3. Add the egg mixture to the butter and sugar in stages, beating well in between each addition. If the mixture looks as if it is about to curdle, add a tablespoon of the flour as you mix in the eggs.

4. Fold in the candied peel or dried fruit and the flour.

5. Spoon the mixture into the prepared pan and bake for about 1 hour. (After about 45 minutes, test by inserting a toothpick or knife into the center of the cake. When it comes out clean, the cake is done.) Remove from the oven and allow to cool in the pan. The cake is very good eaten while still warm. Otherwise, store it in an airtight container and let mature for a day or two.

SMALL PUDDINGS

This recipe showcases Emma at her most minimalist when it comes to giving instructions. Fortunately, what we have here is easily recognizable as a variation on the classic pound cake: equal parts by weight of eggs, butter, sugar, and flour. If you use the pound as your chosen weight, you will end up with a very big cake or a large number of small puddings in teacups. A modern "large" egg weighs about two and a half ounces. A mixture made with two such eggs filled eight small soufflé dishes; three eggs would make a dozen. Either she was being careless or Emma's cups were very big. Flavor these puddings, if you like, with vanilla extract or grated orange or lemon rind. If you make a fruit or wine sauce to go with them, keep it a little on the tart side as these puddings are sweet.

> 5 ounces (150 g) butter
> 5 ounces (150 g) sugar
> 2 large eggs, beaten
> 5 ounces (150 g) self-rising flour

IN PREPARATION: Preheat oven to 325°F (160°C). Grease eight individual ramekins or teacups.

1. Beat butter and sugar together until light and fluffy.

2. Beat in the eggs a little at a time.

3. Fold in the flour, lightly but thoroughly.

4. Divide the mixture between the prepared dishes or cups, smooth the tops with a knife, and bake for 30-35 minutes. Serve warm.

EMMA'S SIMPLE STYLE OF COOKING BETRAYS HER PRESTIGIOUS WEDGWOOD LINEAGE.

PRESERVES AND PANTRY

IN AN AGE that sees year-round supplies of almost everything, if at a price, it is difficult to appreciate just how important a well-stocked larder was in the mid-nineteenth century. The relatively demanding recipe for preserving sweet oranges makes sense when you realize that this fruit would have been available for only a few short weeks. We have already mentioned that Emma's notebook has instructions for curing and salting pork and beef, she had a method for preserving eggs, and she made a variety of pickles. She notes advice for curing hams from more than one source and probably the bacon Darwin loved was home cured. She used a few commercially made "convenience foods": Harvey's Sauce and anchovy essence were two. However, she also found it useful to write down a recipe for baking powder and to suggest that syrup could be collected while jam making. Fortified with extra sugar and bottled separately, this could be "very good around puddings." Preserved fruit and homemade jams must also have added a welcome touch of sweetness to meals at Down House.

CRANBERRY SAUCE

The cranberry on sale in Britain today is the American cranberry—*Vaccinium macrocarpon*—imported from the United States. Initially known as the indispensable accompaniment to the Thanksgiving turkey, cranberries are now used in a variety of products and have something of a following as a "health" food. They began to be grown commercially in the United States only in the mid-nineteenth century, so we can be reasonably sure that the cranberries used at Down House were not American but from plants of native British species, probably *Vaccinium oxycoccos*. At this point, there is a risk of getting into a botanical tangle, and it is enough to say that this is not the only species found in Northern Europe but that the fruits of both are similar—and very different from their American cultivated relatives. The European cranberries grow wild on low, woody, heather-like plants that flourish on poor, acidic soils on moors, mountains, and bogs. The Scandinavians gather cranberries with an enthusiasm reminiscent of the Eastern European love affair with mushrooms. The fruit is tiny—about a quarter the size of the American—and pretty tough, which explains why Emma suggests cooking them for more than an hour. This toughness means they keep well, so there would have been no problem transporting the berries from Scotland or the north of England. Interestingly, neither Eliza Acton nor Mrs. Beeton mentions the cranberry, so it would seem that, here, Emma is being quite adventurous. While working on these recipes, a fortuitous visit to Norway yielded a generous supply of the tiny red berries from a friend's freezer, so this sauce was made from the wild fruit. You could try a cranberry-gathering expedition, as an expert source consulted for this piece states they can be found in many places, from Scotland to Devon, in suitable conditions. If you use American cranberries, the cooking time can be greatly

reduced, as the fruit breaks down quickly on boiling, popping explosively. Add the sugar, and the whole operation can be completed in ten to fifteen minutes. Some people like to add a little orange rind, finely grated, to the sauce. A dash of port is another suggestion.

> **1 pound (450 g) wild cranberries**
> **½ cup (125 ml) water**
> **9 ounces (250 g) sugar**

1. Bring fruit and water to a boil in a heavy saucepan and simmer gently for 1 hour, by which time the fruit will have begun to break down.

2. Add the sugar and stir until dissolved.

3. Boil for about 20 minutes or until very thick.

4. Pour into sterilized jars.

QUINCE JELLY

The quince has a wonderful mythological pedigree. These clear yellow, pear-shaped fruits were the "golden apples" of the Hesperides, the fruits that cost Atalanta her race, and was the "apple" Paris gave to Aphrodite when he judged her the most beautiful among the gods. A ripe quince has a remarkable fragrance, a few in a bowl will fill a room with a scent reminiscent of Turkish delight and rosewater. The flesh, however, is hard and the flavor astringent—the beauty is only skin-deep. Cook them and they not only turn a pretty coral pink color, but they can be used in many ways, too. The flavor goes particularly well with apples. Traditionally, sauces made with quince have been served with game. The Spanish make a stiff sweetened paste—*membrillo*—that is eaten with cheese. The quince marmalade of English cuisine is a similar, but softer, preserve. Quinces feature in the cuisines of countries throughout the Mediterranean and in the Middle East.

Quince Jelly.

12 quinces peel & core them. Put them in a stew pan with the peel & core & 3 pints of water. Let it simmer 6 hours covered close. Strain through a sieve & to every pint of liquor add 1 lb sugar boil 3 quarters of an hour.

What is left after straining will make marmalade.

Ripe quinces, roughly chopped
1 pound (450 g) sugar for every
 pint of juice

1. Taking out the cores and peeling the quinces seems a waste of time
 if you are then going to add the peelings to the boiling fruit. Don't
 bother. However, you do need to wash the fruit well, as it has an
 almost furry bloom on the skin.

2. Place the chopped quinces in a heavy saucepan and add enough
 water to just cover them.

3. Bring to a boil, put on a lid, and simmer gently for 4 hours, longer
 will do no harm.

4. Strain the liquid and discard the fruit.

5. Return the juice to the saucepan, add the sugar, and bring to a boil.
 Stir until the sugar is dissolved. Remove any scum that appears, then
 boil until the jelly reaches the setting point. Test with a spoonful of
 juice on a cold saucer from time to time. When your sample shows
 signs of setting, remove the pan from the heat.

6. Pour into sterilized jars and seal.

QUINCE MARMALADE
(*with Quince Jelly*)

Emma suggests making quince marmalade with the remains of the fruit from the jelly, but surely the fruit will have lost much of its flavor. It is better to start with fresh quinces. The easy way to make this is with a Mouli or rotary grater. With your Mouli, do not bother to peel and core the quinces. Wash, quarter, and place them in a heavy casserole. There is no need for any water. Put on the lid and bake in a low oven, about 250°F (120°C) until the fruit is very soft. Test with a knife—it may take a couple of hours, depending on your fruit. Put the fruit through the Mouli. You may need to do this in batches if you have a large quantity. The Mouli will take care of all the cores, seeds, etc. To every pound of pulp, add twelve ounces (340 g) of sugar. Bring to a boil and, stirring constantly, cook until thick. This may take about an hour, maybe less. As there was no extra water, you have less moisture to reduce than Emma would have had. You need to keep stirring to avoid burning the mixture, and wrap a towel around your stirring hand because the marmalade pops and splutters. When it has thickened, pour into sterilized jars and seal.

PRESERVED QUINCES

Unless your preserving jar is very large, or your quinces remarkably small, you will be better off cutting your fruit into large chunks. You will be able to pack more fruit into your jars and you will need less syrup. Wash the fruit and, this time, you will need to peel and core them but don't throw these bits away.

Ripe quinces and sugar

IN PREPARATION: Preheat oven to 275°F (135°C).

1. Place the chunks of fruit in a saucepan, cover with water, and bring to a boil. Simmer for 5-10 minutes. Strain the fruit, reserving the water they were cooked in. This preliminary poaching will reduce the time needed in the oven and add extra flavor to the syrup.

2. Pack the fruit into preserving jars, put the lids on loosely, and place the jars in a roasting pan with about 1 inch (2.5 cm) of water in it. Place the pan with the jars in the oven and cook until the fruit is soft, but not collapsing.

3. While the fruit is in the oven, add the cores and peelings to the poaching water, bring all to a boil, and simmer for about ¾ hour. Strain the liquid and discard the peelings.

4. For every 2 cups (500 ml) of juice, add 2 pounds (900 g) of sugar. Bring to a boil, stirring until the sugar is dissolved, and cook for 15 minutes.

5. When the fruit is done, remove the jars from the oven and immediately pour in enough syrup to cover the fruit and fill the jars right up to the top. Seal them.

6. Save any leftover syrup. In sterilized jars, it will keep for months, or you can freeze it in small amounts. Use it to add a touch of quince fragrance to fruit salads, apple dishes, sauces, etc.

THERE IS NOTHING MORE PLEASING TO THE EYE THAN A NEATLY STOCKED PANTRY OF BEAUTIFULLY COLORED PRESERVES.

RASPBERRY JAM

A bowl of fresh raspberries, the lightest dusting of sugar, and softly whipped cream—this is surely one of the simplest and best of summer desserts. So it seems almost extravagant of effort and fruit to turn raspberries into jam. They are not the most obliging of fruits either, being low in pectin, a carbohydrate that greatly helps the setting process. It is all too easy to end up stirring a bubbling pan, surrounded by a collection of sticky saucers and spoons, watching for that elusive puckering film on the surface of your sample that tells you the jam will set. The aim is to boil for the minimum time and preserve the maximum flavor. The penalty of failure is to start again the following morning or reconcile yourself to more raspberry sauce than you could possibly need or want. Modern preserving sugars help greatly, but nineteenth-century cooks had another solution: Emma's recipe includes red currant juice. Red currants are not only naturally blessed with a good supply of pectin, the juice also adds a wonderful piquancy to the flavor. The result is simply the best raspberry jam ever tasted, well worth the extra work involved in producing the juice. These quantities should makes about four pounds (1.8 kg) of jam.

3 pounds (1.4 kg) red currants
3 pounds (1.4 kg) raspberries
3 pounds (1.4 kg) sugar

1. Wash the red currants and strip them from their stems. Cook them in a saucepan gently over medium heat until the fruit softens and the juice runs. Strain overnight through a double thickness of cheesecloth.

2. Mix the raspberries with 2¼ pounds (1 kg) of sugar and leave overnight.

3. Add 2 cups (500 ml) of the red currant juice and the remaining 12 ounces (340 g) of sugar to the raspberry/sugar mixture and heat gently, stirring until the sugar is dissolved. Bring the jam to a boil and cook, stirring often, until it sets. (About 35 minutes should be enough, but the timing may vary. You can use a sugar thermometer, otherwise test samples on a cold saucer.)

4. Pour into sterilized jars. Cover immediately while the jam is still very hot. This will give you a good seal, and the jam should keep well for months.

AND SOMETHING DIFFERENT

COLD CREAM

Emma's daughter, Henrietta, remembers the well-stocked "physic cupboard" at Down House and how she enjoyed helping to weigh and measure ingredients for the medicines made by her mother. Rolling rhubarb pills gave her particular pleasure. The making of simple homemade remedies would have been a skill expected of a good housekeeper and mother. Emma was known for her kindness and generosity to the less fortunate in the surrounding areas of Down. There were "dainties" for the ailing, and medical comforts and basic medicines for the sick. The recipes, or prescriptions, for these were recorded in an old, red notebook. Many of them had come from Darwin's father, a well-respected doctor in Shrewsbury. The recipe for Cold Cream must surely have been intended for this book and mistakenly found its way into the company of custards and jellies. Recent times have seen a great revival of interest in herbal and "natural" cosmetics and health supplements. Perhaps we have been influenced by this, but for whatever reason, we decided to make Emma's Cold Cream.

Cold cream

6 dr. spermacete
2 dr. white wax
3 oz oil almonds
1/4 Rose water

melted altogether
& beat up till cold

¾ fluid ounce (6 dr.) spermaceti
¼ fluid ounce (2 dr.) white wax
3 fluid ounces (90 ml) almond oil
1 tablespoon rosewater

The amounts needed of the first two ingredients are very small: a drachm (dram) = 1/8 of an ounce. A beekeeping friend supplied the wax, not white, but that seemed unimportant. The almond oil came from a local health food store. So far, so good. The spermaceti was more difficult. This is a fatty substance found in the head of the sperm whale, an animal definitely now on the forbidden list. We had to find a substitute. After some research and much helpful advice we found a "compounding vehicle," a base cream to which other ingredients could be added. Sadly, it meant that we had moved away from a truly homemade cream. The wax melted easily but tended to solidify when anything else was added, even while everything was still being heated. The almond oil was surprisingly odorless, so the rosewater must have been included to add some perfume to the mix, probably necessary if the spermaceti was smelly. The unit of measurement in the manuscript for the rosewater is indistinct. We were bold and added a tablespoonful. The smell was faint, but pleasant. After a good deal of heating and stirring, in desperation, we sieved the cream to get rid of the tiny particles of wax. The resulting cream was good. It seemed a little oily when first applied, but was quickly absorbed and left the skin feeling soft and smooth. All our "guinea pigs," men and women, liked the cream. One, who had been working with cement, was particularly impressed. Most used it as a hand cream but there seemed no reason why it could not be used as a cleanser to remove makeup. The range of organic and herbal cosmetics found in health shops and department stores means that there is little point in trying to reproduce Emma's cream today, but it was an interesting and amusing exercise and gave us some insight into another aspect of life in Down House.

REFERENCES

ABBREVIATIONS USED IN REFERENCES:

Charles Darwin (CD), Emma Wedgwood (EW), Emma Darwin (ED)

1. Hughes, K., *The Short Life and Long Times of Mrs. Beeton* (London: Harper, 2005), p. 190.

2. *The Correspondence of Charles Darwin*, Vol. 2 1837–1843 (Cambridge: Cambridge University Press, 1986), p. 263, CD to Charles Lyell.

3. *Order of the Proceedings at the Darwin Celebration Held at Cambridge, June 22–June 24, 1909* (Cambridge: Cambridge University Press, 1909), p.19.

4. Healey, E., *Emma Darwin: The Inspirational Wife of a Genius* (London: Headline, 2001).

5. Litchfield, H., *Emma Darwin: A Century of Family Letters 1792–1896*, Vol. II (London: John Murray, 1915), p. 172.

6. Litchfield, H., p. 45.

7. *Correspondence*, Vol. 2, p. 444. Appendix IV.

8. *Correspondence*, Vol. 2, p. 115. Robert Waring Darwin to Josiah Wedgwood II.

9. *Correspondence*, Vol. 2, p. 147. CD to EW.

10. *Correspondence*, Vol. 2, p. 160. CD to EW.

11. *Correspondence*, Vol. 2, p. 165. CD to EW.

12. *Correspondence*, Vol. 10, p. 238. J.D. Hooker to CD.

13. *Correspondence*, Vol. 10, p. 245. CD to J.D. Hooker.

14. Litchfield, H., p. 7.

15. Barlow, N. (ed.), *The Autobiography of Charles Darwin, 1809–1882* (London: Collins, 1958), p. 141.

16. *Correspondence*, Vol. 2, p. 324. CD to Catherine Darwin.

17. Litchfield, H., p. 44.

18. Raverat, G., *Period Piece: A Cambridge Childhood* (London: Faber & Faber, 1960), p. 141.

19. *Correspondence*, Vol. II, p. 296. CD to ED.

20. Keynes, R., *Annie's Box: Charles Darwin, his Daughter and Human Evolution* (London: Fourth Estate, 2001), p. 71.

21. Litchfield, H., p. 99.

22. Litchfield, H., p. 97.

23. Orego, F., & Quintana, "C. Darwin's illness: a final diagnosis." *Notes & Records of the Royal Society*, 2007, p. 61, 23–29.

24. Bowlby, J., *Charles Darwin: A Biography* (London: Hutchison, 1990).

25. Raverat, G., p. 122.

26. Barlow, N. (ed.) *Autobiography*, p. 144.

27. Litchfield, H., p. 39.

28. Litchfield, H., p. 41.

29. Litchfield, H., p. 193.

30. Barlow, N. (ed.) *Autobiography*, p. 115.

31. Aveling, E. *The Religious Views of Charles Darwin* (London: Freethought, 1884).

32. *Correspondence*, Vol. 11, p. 691. ED to W.D. Fox.

33. *Correspondence*, Vol. 2, p. 263. CD to ED.

34. Keynes, R., p. 110.

35. Acton, E., *Modern Cooking for Private Families* (Lewes, E. Sussex: Southiver, 1993).

36. Beeton, I., *Beeton's Book of Household Management* (London: Beeton, 1861) (Facsimile published by Cape, 1968).

37. Darwin, F., *Life and Letters of Charles Darwin,* Vol. I (London: Murray, 1888), p. 118.

38. Atkins, H., *Down: The House of the Darwins* (London: Royal College of Surgeons of England, 1974).

39. Litchfield, H., p. 205.

40. Litchfield, H., p. 171–172.

BIBLIOGRAPHY

Acton, E., *Modern Cooking for Private Families*. Lewes, E. Sussex: Southiver, 1993.

Atkins, H. *Down: The House of the Darwins*. London: Royal College of Surgeons of England, 1974.

Barlow, N. (ed.) *The Autobiography of Charles Darwin 1809–1882*. London: Collins, 1958.

Beeton, I. *Beeton's book of Household Management*. London: Beeton, 1861. (Facsimile published by Cape, 1968)

Bowlby, J. *Charles Darwin: A Biography*. London: Hutchison, 1990.

Browne, J. *Charles Darwin: Voyaging*. London: Jonathan Cape, 1995.

Browne, J. *Charles Darwin: The Power of Place*. London: Jonathan Cape, 2002.

The Correspondence of Charles Darwin. Vol. 1 (ed. by Burkhardt, F., & Smith, S.) Cambridge: Cambridge University Press, 1985.

Davidson, A. *The Oxford Companion to Food*. Oxford: Oxford University Press, 1999.

Desmond, A., & Moore, J. *Darwin*. London: Michael Joseph, 1991.

Flanders, J. *The Victorian House*. London: HarperCollins, 2003.

Grigson, J. *English Food*. London: Penguin, 1992.

Hartley, D. *Food in England*. London: Macdonald & Jane's, 1954.

Healey, E. *Emma Darwin: The Inspirational Wife of a Genius*. London: Headline, 2001.

Hughes, K. *The Short Life and Long Times of Mrs. Beeton*. London: Harper, 2005.

Irvine, W. *Apes, Angels, and Victorians*. London: Weidenfeld & Nicolson, 1955.

Keynes, R. *Annie's Box: Charles Darwin, his Daughter and Human Evolution*. London: Fourth Estate, 2001.

Kiple, K.F. & Ornelas, K.C. *The Cambridge World History of Food*. Vols. 1 and 2. Cambridge: Cambridge University Press, 2000.

Litchfield, H. *Emma Darwin: A Century of Family Letters 1792–1896*. Vol. 2. London: John Murray, 1915.

Raverat, G. *Period Piece: A Cambridge Childhood*. London: Faber & Faber, 1960.

INDEX

APPENDICES

APPENDIX I: EMMA'S ORIGINAL RECIPES

THE FOLLOWING IS A FACSIMILE REPRODUCTION OF EMMA'S RECIPES IN HER OWN HAND, CONTEXTUAL-
IZING THE AUTHORS' MODERN-DAY MODIFICATIONS INTO HISTORICAL PERSPECTIVE. REPRODUCED BY
PERMISSION OF THE SYNDICS OF CAMBRIDGE UNIVERSITY LIBRARY AND BY WILLIAM HUXLEY DARWIN.

Buttered eggs.

Put a little cream and a little
bit of butter in the saucepan and
let it get pretty hot. And have ready
ready a couple of eggs well beaten,
add a little pepper and salt and
stir into the Butter & cream, and stir it up to
look rough and not to be watery, and
lay it on Buttered toast.

Cheese f paws or Fromage.
1 Ounce and ½ of grated Parmesan
Cheese the same Weight of flour ¾
of an ounce of butter. Cayenne
Pepper and salt mixed up rather fine
with a little milk rolled out very thin
and baked in rather a cool oven.

Fondeau

Boil up half a pint of milk.
Melt in another stew pan a bit of
butter & mix with a table spoonful
of flour. Stir it with the milk
till it is smooth Take it off the fire
put 4 table spoonfuls of grated cheese.
& 2 eggs mix & bake. 20 minutes

Scotch woodcock.
Chop some anchovy very fine;
anchovy paste will do as well, spread
it on buttered toast, beat up the yolks
of two eggs, melt a little butter in good
cream, thicken it with the yolks to
the consistency of a good custard. & pour
it over the toast which is cut in slices.

Fish croquets

Cold fish - pick out the bones - chop very
fine - season with salt & pepper.
Make a little white sauce with a very
little cream to a teaspoonful of flour
1 oz butter stir it on the fire till
it boils. then stir ~~it in the~~ in one
yolk & the fish. turn it out on a plate
till quite cold - make it up in balls
size of egg - roll them in egg, then
in bread crumbs, fry in boiling lard
dish on a napkin with fried parsley.

Fish Overlay.

Take the remains of cold fish and
sauce, place it in a dish alternate with
crumbs of Bread, Pepper and Salt to
taste. Put it into a quick oven
to brown. Three or four small pieces
of butter on the Top.

Chicken & Macaroni.
Carve up a chicken & season it with
a little pepper & salt, Take 8 oz macaroni
& stew it in a little delicate Beef or
a mutton gravy, till it is tender, then
place a ~~larger~~ larger in a good
sized pie dish, lay upon it the
chicken & cover it with the remainder
of the macaroni. Fill up the dish
with gravy, & bake in a moderate
oven for an hour.

Curry
A small table spoonful of curry powder
some lemon juice & peel chopped very fine,
& a little ginger & salt (& an onion).
The chicken cut up & boiled, & the curry
Sauce is made of the broth with a little
flour & butter

French ragout of Mutton

Take about half of the scrag of the neck, breast chump with as little fat as possible. Cut it into pieces an inch square, put into a pan 2 oz of butter or good fat; when melted add two table spoonsful of flour, stir till forming a brownish, add the meat, & stir for 20 minutes, add a little water, not less to cover the meat, one saltspoonful of pepper - 4 do of salt & 4 do of sugar a bunch of 6 sprigs of parsley - stir till boiling let it to simmer. Peel a few turnips & cut into dice fried in fat till rather brown - to be put them in the pan with the meat when it is done - which will be in an hour from the time it is put on - dish up by placing the dice of meat round the turnips & pouring the sauce over - To be served very hot.

5 Veal Cake

Take the best end of a breast, neck, or fillet of Veal boil it, & cut it in 3 pieces, have ready 8 eggs boil'd hard, take the yolks out cut them thro' & slice the whites, a good deal of parsley chopped fine, some lean ham in thin slices, all to be seasoned separately with cayenne, & little nutmeg & salt, have ready a deep dish or pan, butter it, then put in a layer of veal, then a layer of egg, parsley, & ham to yr mind, then veal again, & so on till it is all in, all the bones to be laid on the top, then put it in the oven to bake 3 hours & a half, then take off the bones & press the cake down with a heavy weight till quite cold, the pan to be dipped in warm water — & the cake turned out with great care that the jelly may not be hurt that hangs round the cake. —

Celery Sauce for Boiled Fowls

Boil 6 heads of Celery in salt & water till tender - cut in pieces 2 inches long. Put 1 pint of stock into a stew pan with 2 blades of mace & 1 small bunch herbs to simmer for ½ hr. Then strain the liquor add the celery - thicken it with flour or arrowroot, & just before serving put ½ pint cream & squeeze in a little lemon juice

Italian Vegetable Soup

37

The heart of 6 lettuces & cucumbers pared & cut in quaters 1 Pint green pease a little onion pepper & salt to your taste put all together in a stew pan over a very slow fire for 2 hours Then boil a pint of older peas in good broth gravy with a lump of suger pass them threw a seive into the broth then warm add a little cream to the yolks of 2 eggs boild in mix with the stewed vegetable and heat up all together

Potatoe Rissoles

Boil some potatoes very nicely, then pound them
in a mortar very fine, add a little flour & a little
butter and an egg, mix all well together & roll
it out like paste — Then take some cold beef or
ham, cut it very thin, season it with pepper & salt
roll it up tight, put these rolls into the paste
in the manner of Veal olives, fry them very brown in
clean dripping and send them to table. —

Rice Patties

Blanch the rice in warm water
strain — boil 4 oz of rice in 1 pint cold
milk an oz of butter till tender & the
milk all soaked up. ~~When the milk~~.
When the milk is nearly cold work
it into balls, & cut them with a round
cutter like patties. mix the yolk ~~& white~~
of one egg together, dip & roll in crumbs
boil lard till it will brown a bit of
bread, dip the patties in quickly &
put in the meat, mushrooms very good
inside.

Salad

2 lettuces 1 beetroot - 2 eggs, the white chopped
the yolk smashed with the sauce. a teaspoon
ful of sugar ¼ do of salt ¼ do mustard
3 tablespoonfuls of Vinegar 1 of oil, a
small jug full of cream.

Mr Sanders
Salad.

Lettuce should be dry.
 Put into a table spoon.
salt spoonful — salt
half. Do — mustard.
 Do — sugar
a little pepper.
A table spoonful of mixed vinegar
& Tarragon vinegar. mix well with the
above & put in salad bowl.
Put in lettuce in large pieces (2 inches
or so long) mix well.
Pour on 2 or 3 tablespoonfuls of oil.
& mix thoroughly again.

Stewed Spinage Mrs Sheppard

Pick it quite close, boil it with a little salt till quite tender. Throw it into cold water & take it out immediately. Press it very hard between two trenchers till quite dry, & then beat it to a paste in a mortar. put it into a stew pan with a piece of butter, when the butter is well mixed add a cup full of cream or the yolk of an egg or some good gravy adding a little milk to it.

Turnips Crespelly

Boil and pound them in a mortar Put them on a sieve to drain put one ounce a butter in a stewpan and a little Crame put in your Turnips and make them very hot salt a Cayane peper

Baked Apple Pudding

Peel the apples, take out the cores, fill
the holes with sugar & a little lemon peel
chopped very fine. put them into a dish
in the oven & when nicely done, pour
on them a nice batter not too thick
Bake it in a steady oven for an hour.

Burnt Cream

Take half a pint of cream & 1 table spoon
of flour, stir it over a slow fire till it is
as thick as custard. Beat 2 yolks of
eggs with a little sugar, whip the
whites & put them all in
pour on a flat dish, when cold
put brown sugar on the top & salamander it.

Burnt Rice.

Wash a small tin cupful of Rice and Simmer it in new milk till soft. Add an ounce of Butter the yolks of three eggs ¼ of Shugar, then beat the Whites of 3 Eggs to a froth, and mix them with the Rice, lay it in a flat dish sift some Sugar over it and salamander it till brown.

Compote of Apples

Cut any kind of apples in half, pare, core & put in cold water as you do them, have a pan on the fire with clarified sugar, half sugar half water; boil, skim, & put apples in; do them very gently; when done take them off & let them cool in the sugar, then set them in the ashes: & if the sugar is too thin set it again on the fire & give it the height required. (Dr Hooker): July 1844.

Lady Kynaston's Pudding

5 eggs to a pint of cream - the cream must be boiled & made very sweet & poured upon the eggs: 2 Ounces of sugar boiled with a little water till it candies & put in the bottom of the mould: let the cream stand till it is quite cold - & then pour it in the Mould - Steam it 20 minutes before turning out. ————

Orange Posset.

6

A quart of thick cream, and a 1/4 of pound of sugar, boiled & let it stand till cold - 1/2 a pint of Orange syrup & a glass of white wine mixed together, and put in a basin, & the cream poured upon it thro' a tundish from a great height and not stirred after - Garnish it at the top with slices of orange peel. - It should be made the day before it is wanted. ————

Pears to stew

Pare & take out the core of the pears, & put them in a tin saucepan with water enough to prevent them burning, put to them a little sugar, a little lemon peel, & a few cloves cover the saucepan, & let them stew four or five hours without boiling — They are very good dried in the oven after being stewed — N.B. the Saucepan must never be used for anything else. —————

Cranberry Sauce.

Wash & pick a quart of ripe cranberries & put into a Saucepan with a teacup ful of water. Stew slowly stirring often until they are as thick as marmalade. They require at least an hour & a half to cook. When you take them from the fire sweeten abundantly with white sugar. If sweetened while cooking the colour will be bad, put them into a mould & set aside to get cold.

To make Raspberry Jam

To six pound of Raspberries, 4 pound & a half of sugar pounded & mix it over night — add a quart of currant juice to it, & a pound & half of sugar — Boil it about 3 q.rs of an hour — Scum it well & stir it, not to let it burn — Pour it into the pots hot. —

APPENDIX II: GAS OVEN CONVERSIONS

Centigrade °C	Fahrenheit °F	Gas Mark
140	275	1
150	300	2
160	325	3
180	350	4
190	375	5
200	400	6
220	425	7
230	450	8
240	475	9

CREDITS & ACKNOWLEDGMENTS

CREDITS

Every effort has been made to acknowledge correctly and contact the source and/or copyright holder of each picture, and Glitterati Incorporated apologizes for any unintentional errors or omissions, which will be corrected in future editions of this book.

All photographs are copyright © Adam Forgash, with the following exceptions:

Page 4: copyright © Sarah Morgan Karp; page 8: copyright © Patrick Bateson; page 12: copyright © Sarah Morgan Karp; page 16: copyright © English Heritage Photo Library; page 19: copyright © English Heritage Photo Library; page 20: copyright © English Heritage Photo Library; page 21: copyright © Cambridge University Library; page 22: copyright © English Heritage Photo Library; page 25: copyright © Patrick Bateson; page 26: copyright © English Heritage Photo Library; page 28: copyright © English Heritage Photo Library; page 30: copyright © Cambridge University Library; page 31: From the collection of The LuEsther T. Mertz Library of The New York Botanical Garden, Bronx, New York; page 35: copyright © Sarah Morgan Karp; page 37: From the collection of The LuEsther T. Mertz Library of The New York Botanical Garden, Bronx, New York; page 39: copyright © Tori Reeve; page 40: copyright © Patrick Bateson; page 42: From the collection of The LuEsther T. Mertz Library of The New York Botanical Garden, Bronx, New York; pages 44, 58, 67, 76: copyright © HistoryPicks.com; page 46: copyright © Patrick Bateson; page 52: copyright © Sarah Morgan Karp; page 65: copyright © Patrick Bateson; page 80: copyright © Patrick Bateson; page 85: From the collection of The LuEsther T. Mertz Library of The New York Botanical Garden, Bronx, New York; page 86: From the collection of The LuEsther T. Mertz Library of The New York Botanical Garden, Bronx, New York; page 87: copyright © Patrick Bateson; page 88: copyright © Sarah Morgan Karp; page 91: From the collection of The LuEsther T. Mertz Library of The New York Botanical Garden, Bronx, New York; page 103: From the collection of The LuEsther T. Mertz Library of The New York Botanical Garden, Bronx, New York; page 108: From the collection of The LuEsther T. Mertz Library of The New York Botanical Garden, Bronx, New York; page 110: copyright © Sarah Morgan Karp; page 113: From the collection of The LuEsther T. Mertz Library of The New York Botanical Garden, Bronx, New York; page 114: copyright © The LuEsther T. Mertz Library of The New York Botanical Garden, Bronx, New York; page 119: From the collection of The LuEsther T. Mertz Library of The New York Botanical Garden, Bronx, New York; page 124: copyright © Sarah Morgan Karp; page 137: copyright © Patrick Bateson; page 147: From the collection of The LuEsther

T. Mertz Library of The New York Botanical Garden, Bronx, New York; page 149: From the collection of The LuEsther T. Mertz Library of The New York Botanical Garden, Bronx, New York; page 153: copyright © Sarah Morgan Karp; page 155: From the collection of The LuEsther T. Mertz Library of The New York Botanical Garden, Bronx, New York; page 157: copyright © Patrick Bateson; page 163: copyright © Patrick Bateson; page 164: copyright © Sarah Morgan Karp.

Reproductions of the original recipes in Appendix I and the following pages: 33, 36, 55, 95, 105, 117, 127, 128, 134, 144, 158,166 were graciously supplied by and reprinted with permission by the Syndics of Cambridge University Library and William Huxley Darwin.

ACKNOWLEDGMENTS

This book would not have seen the light of day without the generous permission, given by William Huxley Darwin, to use Emma Darwin's original manuscript. The recipes are reproduced by permission of the Syndics of Cambridge University Library. At the Cambridge University Library, we must thank Peter Fox, University Librarian, Adam Perkins of Scientific Manuscripts, and Alison Pearn of the Darwin Correspondence Project. At the Cambridge University Botanic Garden, Director John Parker gave us valuable help with illustrations. Tori Reeve, of English Heritage, was unstinting in her help—even taking photographs of the Darwin china for us. We are grateful to her and also to Jonathan Butler of the English Heritage Photo Library. In the United States, we thank the New York Botanical Garden, for their generous help with illustrations and, especially, Stephen Sinon, for sharing his extensive knowledge of the holdings of the Garden Library. We were only too conscious, as we embarked on this book, that we were venturing into territory already explored by many distinguished scholars. We hope we may be forgiven our failings and are deeply grateful to all who helped us. Particular thanks go to those who read drafts of our manuscript and gave advice and encouragement: Randal Keynes, Susan Allenby, William Bynum, Edna Healey, and Andrew Jones.

Many others helped us, in ways too numerous to list in detail, from giving advice on making home-made cold cream to supplying Norwegian wild cranberries. We owe our sincere thanks to Elizabeth Copeland, Susan Fraser, Sue Gordon, Elizabeth Hodder, David Kohn, Peter Lachmann, Mons Lie, Philip Oswald, John Palmer, David Pazmino, Elodie Stanley, and Mark Thomas.

Finally, the encouragement and never-failing enthusiasm for the project of our publisher, Marta Hallett, kept us going through the occasional moment of self-doubt. We thank her most warmly. As for our husbands, who nobly ate their way through Emma's dishes while also giving practical help with IT and photography, quite simply, we could not have done it without them.